Medardo Rosso

Medardo Rosso

Curated by Luciano Caramel

A National Touring Exhibition from The South Bank Centre, London 1994

Exhibition Tour

Whitechapel Art Gallery, London
25 February – 24 April 1994

Scottish National Gallery of Modern Art, Edinburgh
5 May – 26 June

The Henry Moore Institute, Leeds
14 July – 20 August

A National Touring Exhibition from The South Bank Centre

Exhibition selected by Luciano Caramel
Exhibition organised by Ann Jones and Leigh Markopoulos
Education Officer Helen Luckett
Catalogue designed by Crispin Rose-Innes Limited
Printed in England by Penshurst Press

Photographs by Studio Aleph (Como), Peter Bellamy, Enrico
Cattaneo, Galleria Pieter Coray, Studio Crabb, David Flynn,
Jean-Louis Losi, Joris Luyten, Paolo Monti, Foto Saporetti

© 1994 The South Bank Centre, Luciano Caramel, Vanessa
Nicolson, Tony Cragg and Derek Pullen
© DACS, 1994

ISBN 1 85332 115 X

A full list of Arts Council and South Bank Centre publications
may be obtained from: Publications, The South Bank Centre,
Royal Festival Hall, London SE1 8XX

Cover image: *The Flesh of Others [Carne Altrui]* 1883, wax
(cat. no. 11)

CONTENTS

THE ART OF COMMUNICATION

BT makes communication possible across the length and breadth of the globe, across time and space.

Working as partners, National Touring Exhibitions and BT help to bring the highest quality art within reach of communities throughout the UK.

National Touring Exhibitions and BT are striving to open new doors and enable even more people to experience art, thereby enhancing both verbal and visual communication.

NATIONAL TOURING EXHIBITIONS *Sponsored by* **BT**
ORGANISED BY THE SOUTH BANK CENTRE
FOR THE ARTS COUNCIL OF GREAT BRITAIN

FOREWORD

At the time of Rodin's death in 1917, Apollinaire declared 'Medardo Rosso is now the greatest living sculptor'. Rosso's sculptures have been much admired by artists from Degas and Boccioni to Tony Cragg; however, they have not been seen widely outside Italy and this will be the first time that Rosso's work has been exhibited in depth in Britain.

Rosso is generally regarded as one of the pioneers of modern sculpture. The aim of the exhibition is to show a broad cross-section of his work, while exploring his use of different media to approach the same subjects. His method of working, modelling wax over plaster casts, was highly unusual, enabling him to create subtle effects of light and movement in his sculptures. This approach not only linked him with the Impressionists, but also looked forward to the work of the Futurists.

The exhibition would not have been possible without the collaboration of Professor Luciano Caramel of the Catholic University of Milan. Professor Caramel, who is an acknowledged authority on Rosso's work and on the sometimes complicated questions of dating, has selected the exhibition and written the main catalogue text. More than that, he has been the source of unfailing support and advice on every aspect of the exhibition. We should like to thank Vanessa Nicolson for helping in many ways and contributing a thoughtful essay on Rosso's drawings. We are also grateful to Derek Pullen for providing the first detailed discussion in English of the sculptural techniques used by Rosso, and to the sculptor Tony Cragg for writing a personal appreciation of Rosso's work.

Many of the sculptures are very fragile and we are extremely grateful to all the lenders for generously allowing them to be included in the exhibition. We are especially grateful to the artist's great-granddaughter Franca Parravicini and her daughter Danila Marsure for lending so many works from their private museum in Barzio and for assisting in numerous other ways. We should also like to thank the Henry Moore Foundation for its generous support of the exhibition and the Accademia Italiana for its advice and assistance.

Finally, we should like to thank many others who have contributed their knowledge and expertise: Kate Banks, Paul Bonaventura, Richard Calvocoressi, Pieter Coray, Roberta Cremoncini, Patrick Elliot, Marco Fagioli, Brendan Griggs, David and Anne Grob, Robert Hopper, Jonathan Keates, Catherine Lampert, Rosa Maria Letts, Giuseppe Panzironi, Andrew Patrizio, James Peto, Seiji Tanaka, Laura Tansini, Matilde and Francesco Tedeschi, Luisa Trabucchi and Douglas Walla.

Henry Meyric Hughes
Director of Exhibitions

Ann Jones
Exhibition Organiser

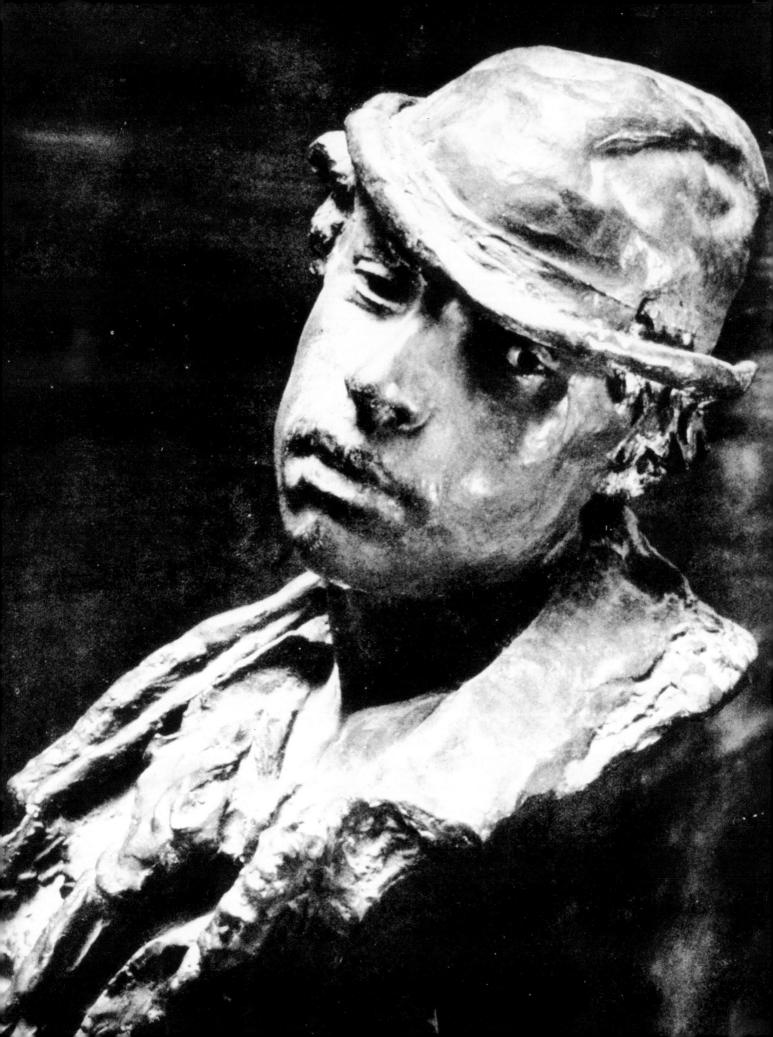

The Sculptural Revolution of Medardo Rosso

LUCIANO CARAMEL

Medardo Rosso and Impressionism in Sculpture

Medardo Rosso was 'the only great modern sculptor to try to open up a wider perspective for sculpture and to convey, through modelling, the influence of a particular ambience and the atmospheric features binding it to the subject matter'. His work was 'revolutionary' – 'not a question, in this case, of heroes and symbols, but of the surface of a woman's or a child's face signalling a spatial freedom destined to achieve a far greater significance in the annals of the human spirit than our era could ever have given it.' This statement was made by Umberto Boccioni in his *Technical Manifesto of Futurist Sculpture* (1912).[1] The great Italian painter and sculptor, at the height of his powers as a Futurist, accurately identified the innovative features of Rosso's work and the germ for future development contained in the solutions he found to overcome the notion of sculpture as something self-contained and impervious to the environment and surrounding atmosphere. In the same year Boccioni had himself tried to introduce into sculpture a tension between internal sculptural space and the space beyond. This is seen in works such as *Head + House + Light* (1912), *Fusion of a Head and a Window* (1912), and *Abstract Voids and Solids of a Head* (exhibited 1913) – all since destroyed – as well as *Ungraceful* (1912) (fig. 1) and *Development of a Bottle in Space* (1912-13). It is also apparent in the group of sculptures: *Form: Force of a Bottle* (1913), *Spiral Expansion of Speeding Muscles* (1913) – also destroyed – and *Unique Forms of Continuity in Space* (1913), as well as the mixed media work *Horse + Houses* (1913-14).[2] Rosso's work had served as one of Boccioni's principal points of departure (along with Picasso's *Head of a Woman* of 1909) (fig. 2). The exploratory nature of Rosso's work, together with the lucid theoretical notes scattered unsystematically throughout his writings, had served to anticipate Boccioni's development of close correlations between matter-energy and movement; space and time; and the three-dimensional object and its surrounding space.

The origins of Rosso's innovations may be traced back, not only to his desire to transcend the 'statuesque' quality of sculpture deriving from classical antiquity and the Renaissance, but to his awareness of the interaction between

The Spiv [El Locch] c. 1881-82, bronze (cat. no. 1)

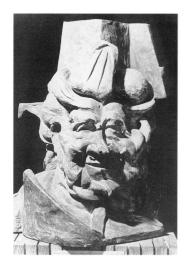

fig.1 Umberto Boccioni *Ungraceful*
1912 Galleria Nazionale d'Arte
Moderna, Rome

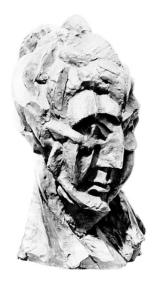

fig.2 Pablo Picasso *Head of a Woman*
1909 Musée Picasso, Paris

sight, sensation and action. In this, as in many other respects, Rosso remained attached to the main tenets of nineteenth-century positivism. He would scarcely have sympathised with Henry Bergson's notions of 'memory' and 'duration', which enabled Boccioni to harness both observation and recollection to the shifting planes of experiential dynamics. Neither could he have conceived of the Futurist sculptor's 'rhythmic distribution of the force within objects, dominated and driven by the very energy of the state of mind towards creating an emotion' or 'intuitive search for a unique form of continuity in space'.[3]

Likewise, Rosso could not have shared Picasso's urge to analyse and construct planes, as seen in the latter's *Head of a Woman* (fig.2), which, for all its surprising affinities to the investigations which Rosso began in the 1880s into the relation of the object to the surrounding space, was probably more related to the influence of Cézanne. Rosso never succeeded in moving away from the natural object. Boccioni grasped this clearly when he qualified his recognition of Rosso's innovative genius in the *Manifesto of Futurist Sculpture* with the comment that 'the Impressionists' need for experiment has unfortunately limited the researchers of Medardo Rosso to a species of both high and low relief. This shows that he still conceives of the figure as a world to itself, with a traditional foundation, imbued with descriptive aims. Rosso's resolution, although very important, springs from pictorial concepts, and ignores the problem of constructing planes. The sensitive touch of the thumb, imitating the lightness of Impressionist brushwork, gives a sense of vibrant immediacy to his works, but necessitates a rapid execution from life which deprives a work of art of any elements of universality. Consequently he has fallen prey to the same qualities and defects as the Impressionist painters; although it is from their experiments that our own aesthetic revolution springs, we shall move away to a diametrically opposed position'.[4]

Boccioni's reference to Impressionism is not altogether without substance. However, this is less a defect than a consequence of Rosso's grounding in an historical context somewhat different from that of the early twentieth century, which saw the birth of Cubism and Futurism, a context which is best defined in chronological terms. It will scarcely do to speak simply of 'Impressionism', particularly since Boccioni's use of the word to suggest a uniform and consistent artistic movement fails to make a proper distinction between the authentic Impressionism of the 1870s and offshoots from the 1890s. Although related, they are quite distinct. Indeed there was such a confusion of ideas around 1900, that it must have been difficult to distinguish clearly between notions of Impressionism in painting and sculpture. As far as Rosso was concerned, this problem had already arisen in the late 1880s, when he was first dubbed an 'Impressionist' and even credited with the creation of Impressionist sculpture[5]. But the problem began to

assume greater significance from 1898 onwards, in the wake of the polemics surrounding the public presentation of Rodin's plaster model for *Balzac* and its rejection by the committee which had commissioned it in 1891. The work was criticised for its summary execution and lack of respect for so high a subject – in short, for its 'impressionistic' appearance. Edmond Claris launched an enquiry in *La Nouvelle Revue* in June 1901, which was then reprinted in a revised version the following year under the imperious title, '*De l'Impressionnisme en Sculpture: Auguste Rodin et Medardo Rosso*'.[6] Here, for the first time, Claris posited the notion of Impressionism in sculpture and attributed its inception to Rodin and Rosso. According to Claris, both artists posed the question of whether sculpture should 'remain subordinate to architecture and ornament', offering nothing more than 'a rigid cast from the model' or whether it should be 'a rendering of sensory impressions, embodying all aspects of whatever it is that gives life to the subject – atmosphere, colour, perspective and feeling'.

Claris cited *Balzac*[7], in particular, in support of his contention that Rodin 'had affirmed that the artist should, above all, draw inspiration from nature and make every effort to find an appropriate language for the impressions derived from nature'. According to Claris, the violent reactions unleashed at the unveiling of *Balzac* 'recalled to those interested in the most recent period of art history the unjust criticisms heaped on painters such as Manet, Monet, Sisley, Pissarro, Vogler and Raffaelli at the outset of their careers, and on the fearless group of painters who merely looked at nature directly, in their own way, with the firm intention simply of expressing and communicating the impressions produced on their own sensibility'. The fame of the early Impressionists emphasises the considerable time-lag between the stylistic renewal in painting and comparable efforts in sculpture. Claris interprets this as evidence for the importance of the innovations made by Rodin and Rosso in relation to current sculptural practices, which were still anchored in an academic language, decoration, anecdotalism, as well as an ideological treatment of social subjects. Yet he makes the simple and dangerous mistake of failing to differentiate between early Impressionism of the period up to the 1880s, which had concentrated on freshness of imagery and straightforward recording of impressions, and subsequent stylistic and historical developments of the movement. This limits the validity of the comparison which Claris makes between Impressionist painting and the sculpture of Rosso and Rodin, which clearly belongs within the context of late Impressionism. His failure to distinguish between the successive phases of Impressionism with regard to Rosso has had lasting repercussions, in that critical discussion of Rosso's work tends to this day to focus on its relation to Impressionism, and specifically to the 'true' Impressionism of the pioneers of that movement. In replying to Claris, Rosso made several references to

fig.3 Letter from Boccioni to Rosso

'impressions', but none to 'Impressionism'[8]: 'The impression you produce on me is not the same, if I happen to see you alone in a garden or amongst others in a salon or in the street. That is all that matters ... and that is why I find it impossible to see all four legs of a horse at the same time or a man as a mannequin isolated in space'. However, statements such as these serve only to bring out the deceptive similarities between the terminology used by the Italian sculptor and that of the Impressionists and to perpetuate the error of situating Rosso's work in the context of early Impressionism.

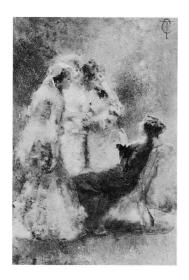

fig. 4 Tranquillo Cremona *High-life*
1877 Galleria d'Arte Moderna, Milan

The Milanese Apprenticeship

Such attempts to align Rosso, however vaguely, with early Impressionism ignore above all the extent of his involvement with the Milanese artistic bohemia, the Scapigliatura, which flourished from the 1860s to the 1880s. The writers, artists and composers who made up this milieu in the Lombard capital were opposed to the bourgeois mentality and reacted in interesting ways which led to a renewal of artistic language in a number of areas.[9] The painters experimented with chromatic dispersals and vaporous atmosphere to notable effect in the cases of Tranquillo Cremona (fig.4) and Daniele Ranzoni, who were the leading figures in this field; whilst Giuseppe Grandi tried to introduce a similar kind of painterly freedom into his sculpture.[10]

Rosso was born in Turin in 1858, but moved to Milan in 1870, where he began to sculpt, attended the Brera Academy and made his home until his departure for Paris in 1889. To understand how he came so close to achieving in sculpture what the French Impressionists had attempted in painting, we should consider in some detail the complex artistic situation in Milan at the time, which was little known outside Italy. This had a decisive influence on the sculptural evolution of the young Rosso in such works as *The Concierge* of 1883 and *Impression of an Omnibus*, probably from the following year. Through the art of the Milanese Scapigliatura, Rosso discovered the basis for his own future development, though this movement was by now entering its final phase: Cremona was dead and Ranzoni, after his return from a long period of work in England, had gone into a severe depression which did not necessarily impede him from creating genuine masterpieces, but meant that he was confined to the small town of Intra on Lake Maggiore. In the paintings of the Scapigliatura artists and the sculpture of Grandi, Rosso discovered radical techniques for blurring the outline, attenuating the edges of intersecting planes and creating a vibrant light and atmosphere, which all contributed to the overall unity of the image. Grandi's example was, therefore, of vital importance to the young Rosso, in helping him to overcome the isolation of the three-dimensional object in space. However, Grandi not only maintained the integrity of volume, but also tried

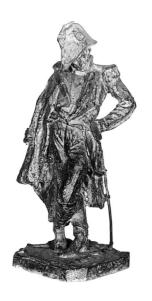

fig. 5 Giuseppe Grandi *Marshal Ney*
1875 Galleria d'Arte Moderna, Milan

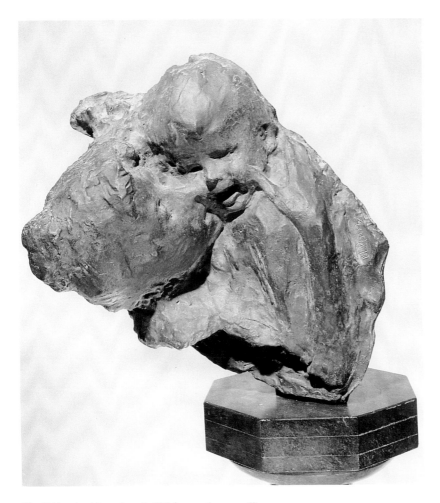

The Golden Age [Aetas Aurea] 1886, bronze (cat. no.18)

to overcome the inertia of polished bronze and uniform modelling and to capture the immediacy of the passing moment. Such works by Grandi as *Marshal Ney* (fig.5), *Lara's Pageboy*, *Monument to Antonio Billia* and the even more radical *Mourner* and *Ivy* of the 1870s, which predated Rosso's first creations,[11] were the direct antecedents of *The Infantryman*, *The Ragamuffin*, *Unemployed Singer* and *Kiss under the Lamp-post* (all 1882-83). These works are represented in this exhibition by outstanding examples deriving from the initial conception: *The Infantryman* is shown in a terracotta version, which reveals the direct hand of the sculptor, in the stage immediately before the plaster model. Grandi's relatively timid innovations prepared the way for Rosso's more mature works of the succeeding period from 1883 and 1886, from *The Concierge* (the bronze cast shown here is the only known example and belonged to Rosso's plaster moulder, Carlo Carabelli) and *Impression of an Omnibus* (destroyed) to *The Sacristan* (1883), *The Flesh of Others* (1883) and *The Golden Age* (1886).

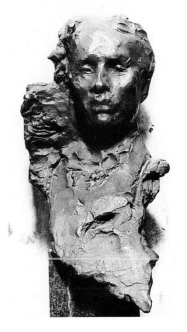

Portrait of Carlo Carabelli [Ritratto di Carlo Carabelli] 1886, bronze (cat. no.17)

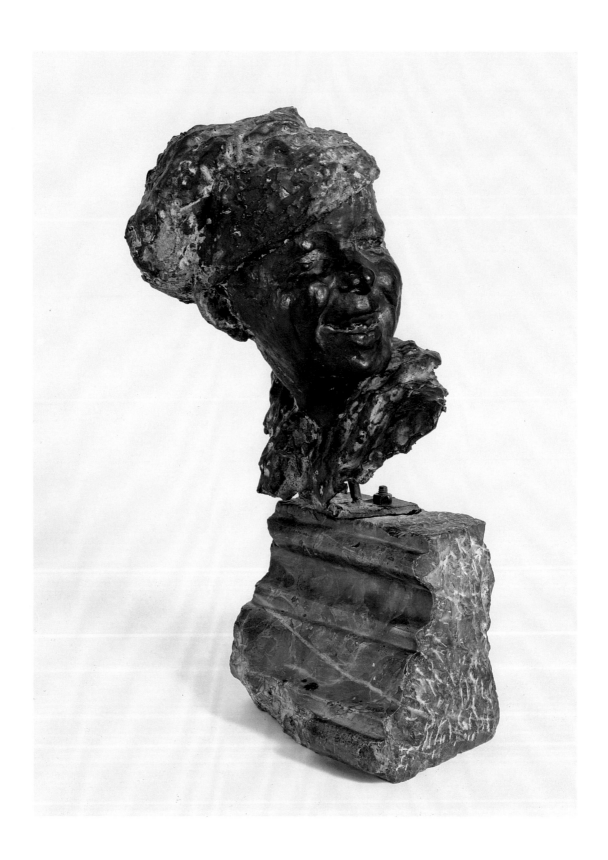

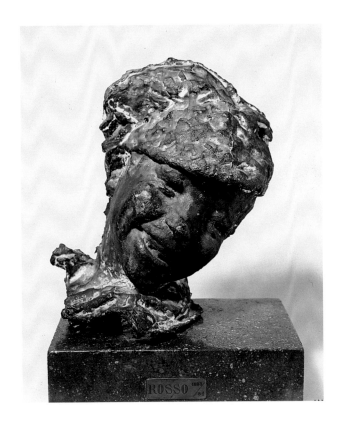

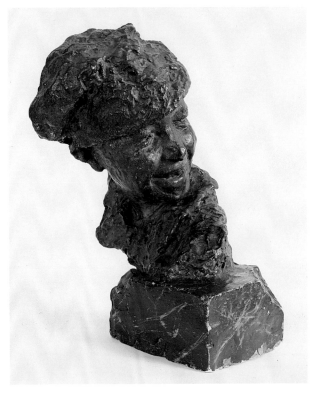

The Ragamuffin [Gavroche or *Il Birichino] 1882–83, bronze (cat. no.2)

The Ragamuffin [Gavroche or *Il Birichino] 1882–83, plaster (cat. no.4)

The Ragamuffin [Gavroche or *Il Birichino] 1882–83, bronze (cat. no.3)

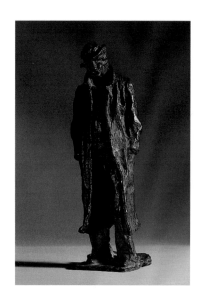

Unemployed Singer [Il Cantant a Spasso]
1882-83, bronze (cat. no.7)

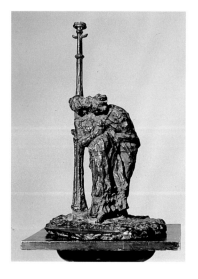

Kiss under the Lamp-post
[Gli Innamorati sotto il Lampione]
1882-83, bronze (cat. no.6)

From this Milanese context, Rosso derived his broadly positivist approach to objective reality, exemplified by his interpretation of visual data and an attitude which clearly links him to the Impressionists, with whose work he might have become acquainted at second hand, via Milanese realist writers such as Felice Cameroni.[12] Rosso made his first journey to Paris in 1886 (there is no documentary evidence for an earlier visit, supposed to have taken place in 1884) in time to see the last Impressionist exhibition which had just opened. However, the work in this show was already strongly characterised by the scientific rigour and structural concerns of Seurat and the Neo-Impressionists. By the time Rosso settled in France in 1889, the Impressionists no longer held centre stage. Rosso's sympathy for his subjects and his emotional involvement with them reflect the influence of his Milanese background as much as anything else. Thus, he described *The Concierge* as 'a creation of light, emotion and shifting perspectives, no longer definable as still life but determined by the fluctuations of our states of mind'.[13] This attitude lies at the origin of his response to Claris: 'The sculptor should communicate through a synthesis of received impressions, everything which makes an impact on his sensibility; when we look at his work we experience the entirety of the emotions he has lived through in observing nature'. Therefore the sculptural innovations transcend the limitations of stylistic and aesthetic choice.[14]

Thus the fusion of figure and atmosphere, with the abolition of contours and dissolution of preconceived volumetric structures in *The Concierge* may be attributed to Rosso's adherence to his conception of the uniqueness and indeterminacy of reality, rather than his preference for swift touch. This is the meaning of Rosso's resolve to 'forget about material substance' reiterated throughout his writings and embodied in his sculpture in his predilection for encapsulating the figure within the overall form, sensitising its planes to the effect of light and producing an interaction between the object itself and the surrounding space. To Rosso 'overcoming matter means capturing the intimate essence of the subject – the explosive release of latent energy'. At the end of his reply to Claris, Rosso says that if he is unable to see 'all four legs of a horse at once', it is because he feels 'that this horse and this man are inseparably linked and integrated into an environment that the artist is compelled to acknowledge'.[15]

Rosso shared with his contemporaries in late nineteenth-century Milan an aspiration to 'investigate the truth' and its underlying ideological, philosophical and moral assumptions, as well as the ambiguities involved in refusing to view 'reality' in isolation from social, economic and political contingencies and historical contradictions. His earliest sculptures were influenced by a naturalist preference for contemporary themes, exemplified in the literary field by Zola, Flaubert, Maupassant and the Goncourts, in

France; and in Italy, by Giovanni Verga, the author of '*I Malavoglia*', and Luigi Capuana, the writer and literary critic, who defended the doctrine of 'Verismo' (the Italian version of French Naturalism) of which Verga was the leading exponent. The Naturalists' themes, and their striving for truth and immediacy, are in marked contrast to the historical and mythological subjects of the day and the stilted manner in which these were executed. Hence Rosso's interest in the 'motif' into which he introduced his own ideological and thematic concerns. His early subjects, drawn from the urban proletariat, reflect his anarchist, socialist, internationalist and republican leanings. *The Spiv* (*El Locch*) is a vagabond without deep moral scruples; *The Ragamuffin* is a roguish little urchin, a 'spiv' in the making; *Unemployed Singer* is one of the jobless; *Kiss under the Lamp-post* shows a young working-class couple; *The Infantryman* is a simple soldier; *The Sacristan* an old drunk; *The Old Man* an aged creature worn down by fatigue and privations, like *The Concierge* and the greengrocer and other 'common folk' riding on the tram in *Impression of an Omnibus*; *The Flesh of Others* is a portrait of a prostitute, to whose world *The Procuress* also belongs.[16]

Works such as these are clearly related to the experimental literature of contemporary Lombardy in which may be discerned, among other things, a similar combination of analytical approach with reforming zeal. The resultant transformation of reality from within encouraged the critic Asor Rosa to refer, appropriately enough in this connection, to the 'expressionist flavour' of Rosso's work. This may be seen in *The Spiv* and is perfectly exemplified in *The Procuress* and *The Old Man*, Rosso's most 'expressive' works, almost to the point of becoming 'expressionist' in their analytical recording of reality. It is not surprising that Cameroni chose *The Old Man* for himself. There are analogies between this sculpture (which Rosso later deemed too material-bound), the related *Procuress* and the writer's theoretical statements in defence of a veracity based on visual data, but comprehensible only to those who possessed the necessary emotional and psychological understanding. Here was the potential for taking things a stage further. At the same time Rosso, whose own early work was not entirely free of the anecdotal, descriptive features common to Italian Verismo, ran the risk of spilling over into effusive sentimentality, as in *The Last Kiss* (1882-83 or 1885) which was inspired by mimetic intentions of such raw directness that the artist went to the extent of including the lover's abandoned slippers on the floor in deference to naturalistic principles. It is even possible to detect surviving traces of Romanticism in the formal devices which Rosso inherited from previous decades and only succeeded in eliminating from his work when he arrived at the radical solutions which began with *Maternal Love* (1883), followed by *The Flesh of Others* and *The Sacristan*. These are most apparent in *The Concierge*, where he succeeded in confronting the subject

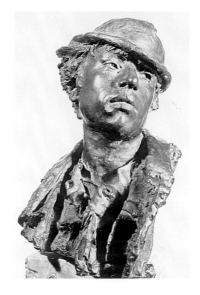

The Spiv [El Locch] c. 1881-82, bronze (cat. no. 1)

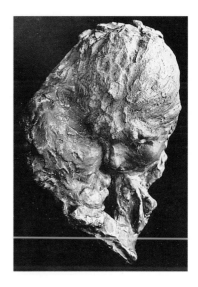

Maternal Love [Amor Materno] 1883, bronze (cat. no. 12)

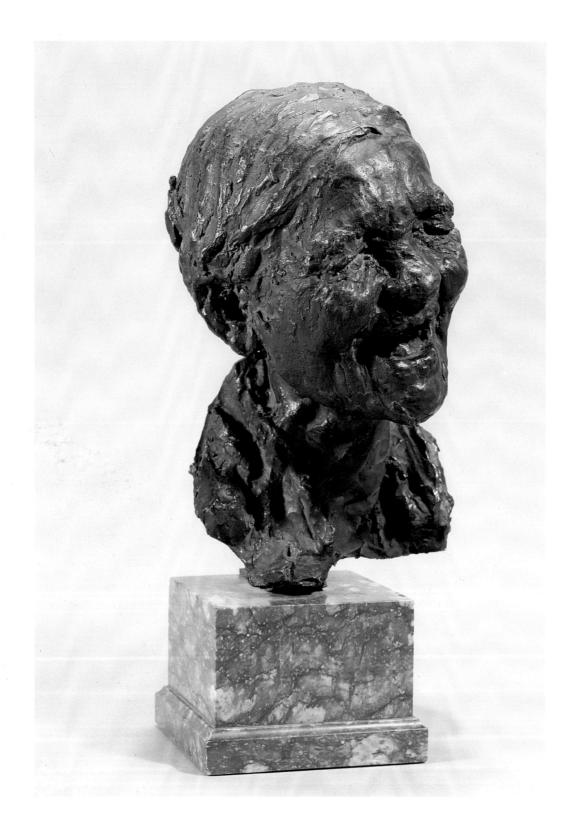

The Procuress [La Ruffiana] 1883, bronze (cat. no.8)

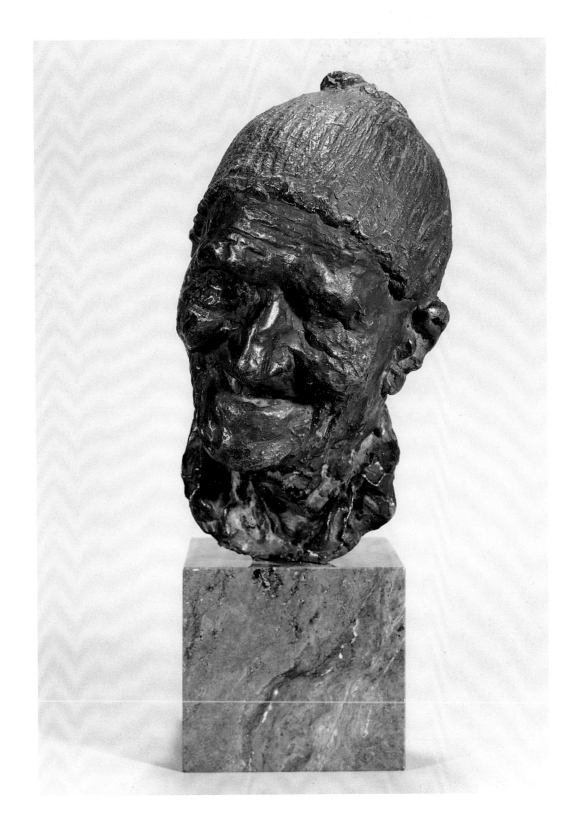

The Old Man [Il Vecchio] 1883, bronze (cat. no.9)

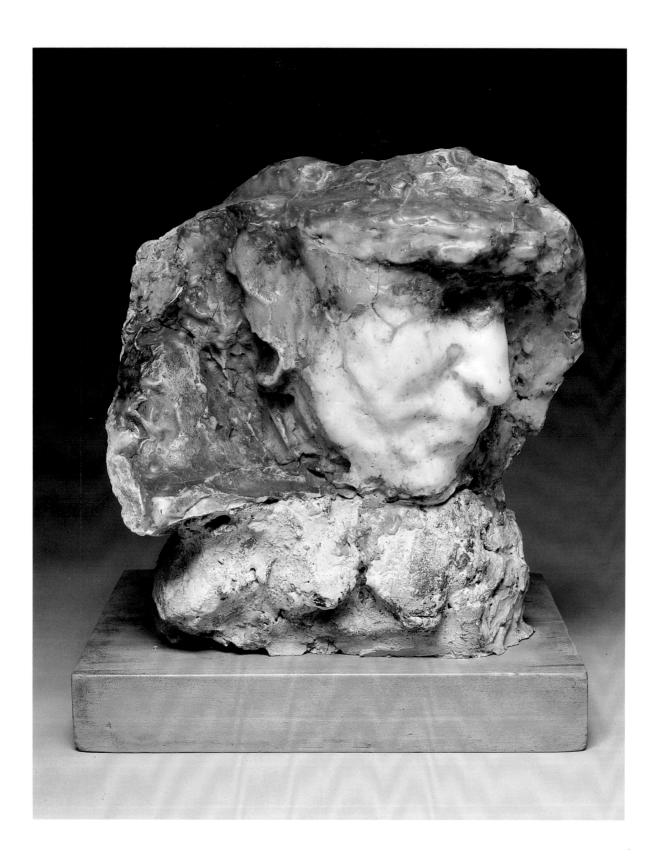

20

head-on and breaking down the traditional isolation of the statue from its surrounding space, in obedience to the internal spatial logic of the work but without sacrificing the principle of three-dimensional verisimilitude. In this way, Rosso went far beyond Grandi's tentative atmospherics and surpassed Cremona and Ranzoni in his use of the third dimension, to break up the skin enveloping the object and establishing a relationship between its internal and external spaces. The image thus became a flattened rendering of the transient 'slice of the life', a vision seemingly conjured up out of nothing and frozen in time, eschewing in its fluid form the nobility of marble and hardness of stone.

In Paris

In 1889 Rosso took up permanent residence in Paris. Here he continued what he had independently begun in a less open cultural climate, freeing himself from involvement with issues of content, poised between late romantic sentiment and naturalist or socialist ideology, the final traces of which were relegated to the margins of his work. *Sick Man in the Hospital* (1889) was probably the first work to be completed after his move to Paris and it was possibly inspired by a period in the Lariboisière hospital. It combines formal devices already tried out in the Milanese years, such as the treatment of the old man's nose and his head, slouched in total fatigue (referring back to *The Sacristan*, *The Concierge* and *Impression of an Omnibus*), with a new attempt at spatial and material cohesion. This is illustrated by the integration of the old man with his armchair and the floor. Similarly, *Sick Child* (1889), which might also date from the artist's stay in hospital, is far more than an essay in sentimentality. The same applies to *Child in the Soup Kitchen* (represented here by the earliest known and most notable extant version), *Sick Man in the Hospital* (represented by an extremely rare wax cast and a version in bronze) and *Sick Child* (represented by plaster, bronze and wax to show how Rosso used different materials to obtain a variety of effects).

These works still draw inspiration from a form of humanitarian socialism, but they provide evidence, above all, of Rosso's decided inability to portray anything in preconceived isolation. A good illustration of this is *Portrait of Henri Rouart* (1889-90). (Rouart was a painter friend of Degas and among the first collectors of Monet, Manet, Pissarro and Renoir. He helped Rosso after his spell in hospital, by offering him studio space and financial support.) This work broadly follows conventional methods of posing, and the truthful likeness of the sitter is determined essentially by his active relationship with the surrounding space and the dissolution of all physical encumbrances in light.

The Flesh of Others [Carne Altrui] 1883, wax (cat. no. 11)

The Sacristan [Lo Scaccino] 1883, bronze (cat. no. 13)

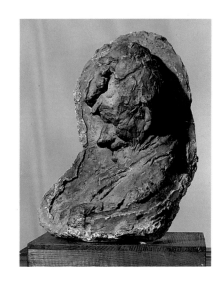

The Sacristan [Lo Scaccino] 1883, plaster (cat. no. 14)

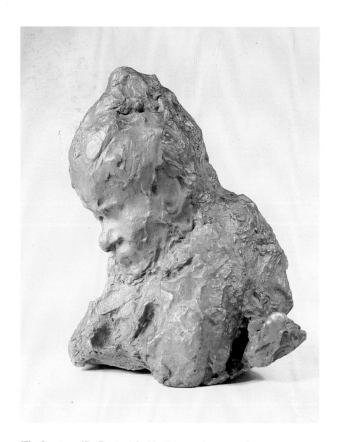

The Concierge [La Portinaia] 1883-84, wax (cat. no. 15)

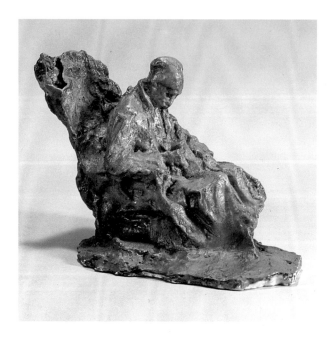

Sick Man in the Hospital [Il Malato all'Ospedale] 1889, wax (cat. no. 20)

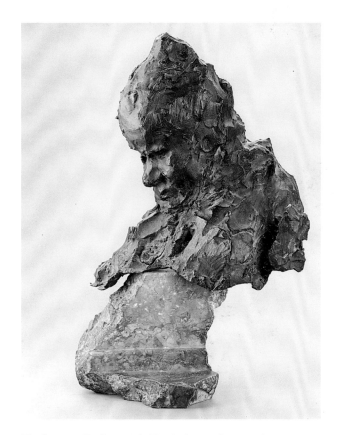

The Concierge [La Portinaia] 1883-84, bronze (cat. no.16)

Sick Man in the Hospital [Il Malato all'Ospedale] 1889, bronze (cat. no.19)

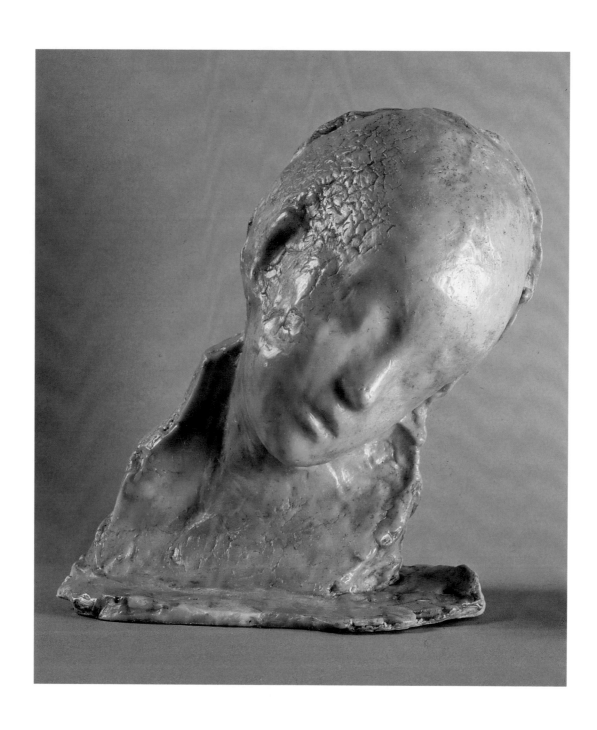

Sick Child [Bambino Malato] 1889, wax (cat. no.22)

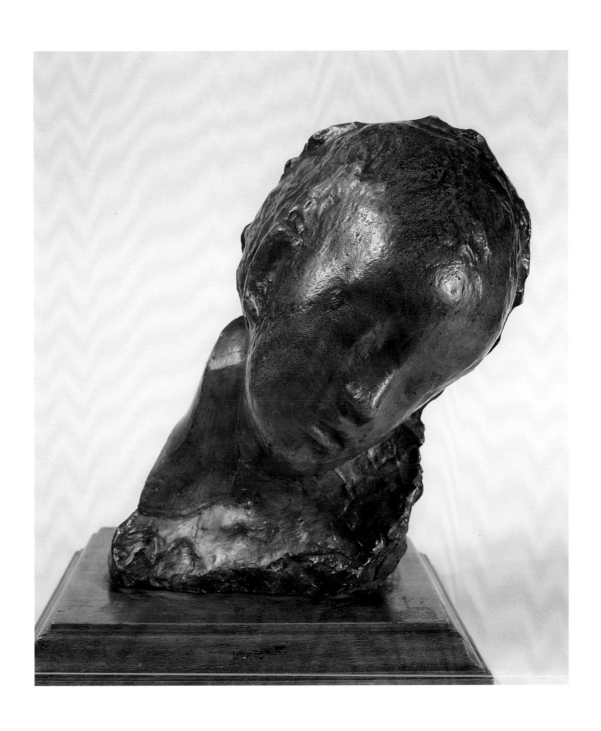

Sick Child [Bambino Malato] 1889, plaster (cat. no. 21)

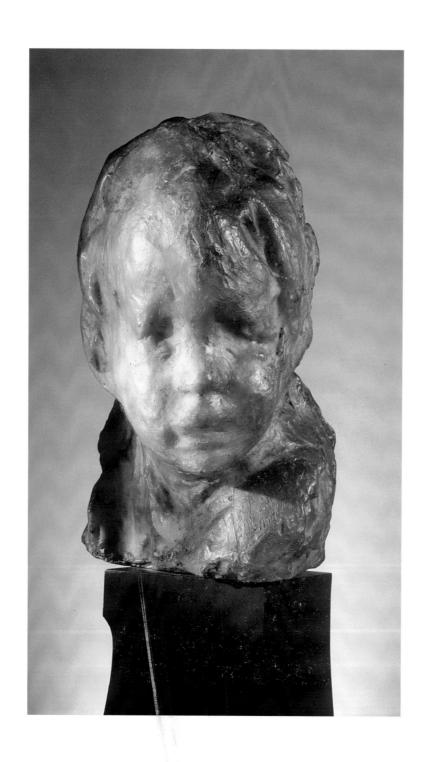

Jewish Boy [Bambino Ebreo] 1892-93, wax (cat. no. 31)

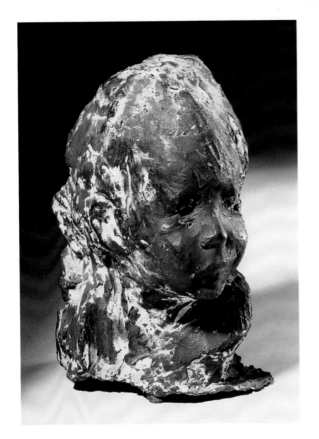

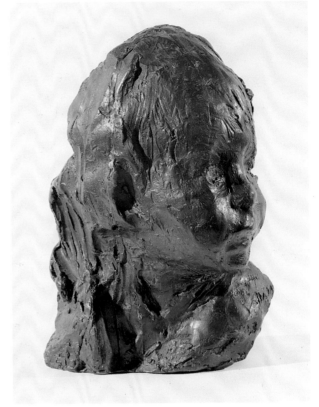

Jewish Boy [Bambino Ebreo] 1892–93, bronze (cat. no. 32) *Jewish Boy [Bambino Ebreo]* 1892–93, wax (cat. no. 33)

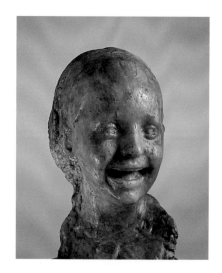

Laughing Child [Bambina che Ride] 1889-90,
wax (cat. no. 25)

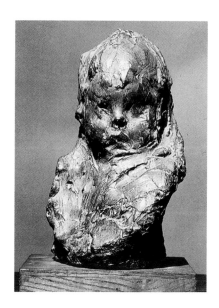

Child in the Sun [Bambino al Sole] 1892,
plaster, Museo Medardo Rosso, Barzio

In other impressions of childhood, such as *Child in the Sun* and *Jewish Boy* (of 1892-93), or womanhood, such as the *Laughing Women* (conceived in 1890-91), Rosso similarly links space with time and captures a life-like immediacy in the dynamics of light, to the point where appearance merges with reality, being with becoming. From here Rosso moved quickly on to the extraordinary synthesis achieved in *Conversation in the Garden* (1896). He attributed the inspiration for this sculpture to a visit which he made to London, which might have been the visit of 1896, for which documentary evidence exists. The elusive *Impression on the Boulevard. Lady with the Veil* (1893), the sturdy *Bookmaker* and *Man Reading* (both 1894) are all either rooted in the material reality – earth to earth, as it were – or dissolved in light, like the *Lady with the Veil*, whose physical outline is summarily captured in a few strokes. Elsewhere the two couples in *Paris at Night*, like the figures in *Conversation in the Garden*, are linked by the almost tangible quality of the surrounding atmosphere which is largely suggested by the effect of instantaneity created by the fleeting 'impression'. Rosso's concern with modern life, the importance he accords to transitory visual effects, his light touch and fluent handling of surfaces all point to the influence of early Impressionism, the delayed impact of which he must have experienced at first hand, on his arrival in Paris. At the same time, the Nabis and the young artists who came into their orbit in the 1890s showed a similar interest in re-establishing contact with daily life. This was the case with Roussel, Vuillard and especially Bonnard, with his paintings of street scenes of 1894-95 and album of lithographs, *Quelques aspects de la vie de Paris*, produced for Vollard in 1895-98.

It is quite plausible to suggest the possibility of a link between the work of the Nabis and Rosso during his first years in Paris. This connection seems to be supported – not withstanding Rosso's poetic originality – by a number of drawings of views of city life, governed by a straightforward engagement with events recorded on the spot, which I have been able to date to those crucial years 1895 and 1896.[17] Executed in Paris and London, they portray men and women walking along the street, carriages, trams, railway and underground stations, bars, restaurants, parks, boulevards and quayside scenes in a wide range of atmospheric conditions. There are also interiors with figures in various attitudes, combing their hair, bent over a suitcase and seated at a desk, as in *Bookmaker* and *Man Reading*, where figures are placed as if seen from above, from right to left. This novel positioning, drastic foreshortening, multiple vantage points and frequent elevation of the angle of vision, contribute to an overall reduction of spatial depth and sharpness of definition. Moreover, there are occasions when the overall simplifications, transparent rendering, unification of effects, flattening of forms and inter-related colour schemes with heightened tonality all point much more directly

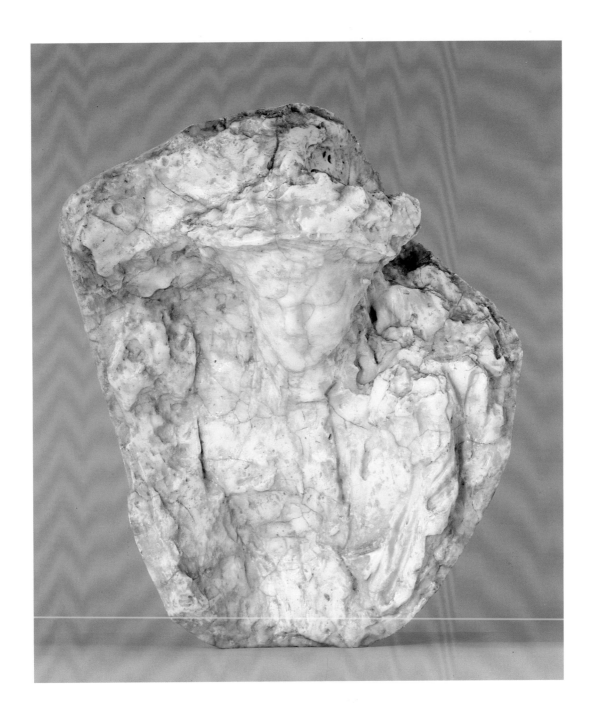

Impression on the Boulevard. Lady with the Veil
[Impression de Boulevard. La Femme à la Voilette] 1893, wax (cat. no.34)

Bookmaker 1894, bronze (cat. no.38)

to the milieu of the Nabis than their Impressionist forebears, as a source of influence and as a spur to the kind of tension precipitating the synthesis achieved in *Bookmaker*, *Man Reading*, *Conversation in the Garden* and *Paris at Night* (fig.6). Moreover, around 1890 Rosso was at the heart of events and developments in the art of some of the leading pioneers of Impressionism in the 1860s and 1870s, such as Cézanne, Monet and Degas. They had passed beyond the immediacy of sensations and were now unable to return to the Impressionism they themselves had formulated, ten or twenty years earlier. Cézanne was now the painter of the *Bathers* and views of Montagne Sainte-Victoire. The spatial conception in his images was constructed through colours which have both light and volume, and are rooted in consciousness rather than external reality and transposed on to another plane, through the mental distillation of momentary sensations. Monet was the painter of the *Cathédrales*. He closed the perspectival window of the Renaissance with his liquid paint-surface and unified everything in an irresistible rush of energy. Degas – above all, the artist of the *Danseuses* since the late 1880s – was increasingly concerned with light, scenic movement and the interaction between context and content. Pastels such as *Women Bathing and Dressing*, of which there is also a sculptural version, invoked the creed of artistic indivisibility postulated by Rosso. It is no accident that Degas should have given Rosso his unprecedented support, in view of their shared belief in the inter-relationship of painting and sculptural discourse, and rejection of fixed categories in which they saw the vestiges of convention and academic tradition.

Man Reading [Uomo che Legge] 1894, wax (cat. no.40)

Conversation in the Garden [Conversazione in Giardino] 1896, bronze (cat. no.41)

THE SCULPTURAL REVOLUTION

Degas was the artist to whom Rosso was closest, in his renewal of modelling techniques at the dawn of a new sculptural style (fig.7). Renoir, in contrast, returned in his late works to the notion of the free-standing, self-sufficient statue as a result of his collaboration with Guino (the only sculptures by Renoir's own hand – the head and medallion of Coco (1907) – are simply a cautious experiment in the manipulation of surfaces). Bourdelle and Troubetzkoy took different paths and the same is true of Rodin, whose work is so different from Rosso's, in its harking back to monumental solidity, its sensual vitality, modelling technique, architectural approach, energetic invasion of space through volume and the consistent objectivity in his images up to the end of the 1890s. This makes nonsense of the frequent claims that there was a close connection between his sculptures and those of Rosso. Nevertheless, there is quite likely to be some truth in the view that Rodin looked at certain sculptures by Rosso, when he was working on the final version of *Balzac* (fig.8). These were probably *Man Reading*, *Bookmaker* and the same silhouette of a man in the *Conversation in the Garden*, all of which are set on the diagonal, compact, free of voids and radical in their treatment of the way in which the figure is joined to the base. Apart from these formal coincidences, however, there is a marked difference between Rosso's early projects and Rodin's 'heroic' statue of the nude male writer. In the latter work, the definitive solution, embodied in the ample dressing gown which gives the work its enveloping unity, is entirely Rodinesque in its overall robust physicality and decisively structural pose. In short, Rodin

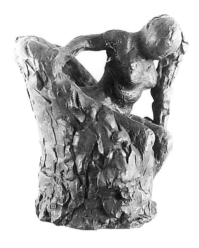

fig.7 Edgar Degas *Woman in Chair* early 1900s

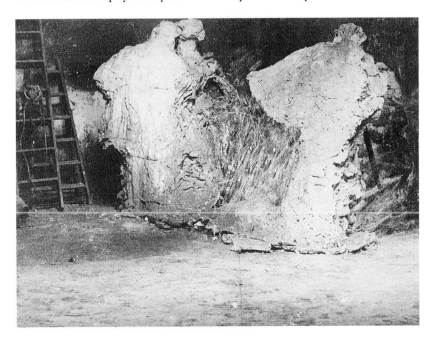

fig.6 Medardo Rosso *Paris at Night* 1895-96

31

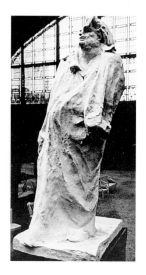

fig.8 Auguste Rodin *Balzac*
(exhibited in the Salon of
1898) Musée d'Orsay, Paris

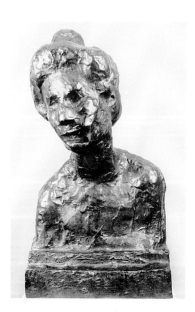

fig.9 Henri Matisse *Bust of a Woman*
1900

remains Rodin. In view of this we should note the comment made in 1922 by Etha Fles, Rosso's friend, great admirer and collector of his works: 'Exaggerated emphasis has been placed on the greater or lesser rivalries between Rodin and Rosso. It seems only natural that thirty years ago the powerful revolutionary ideas of the brilliant Piedmontese should have impressed so many Parisian artists – especially Rodin – the more so since sculpture at the time was becoming increasingly conventional and gave increasing cause for concern. Rodin made the young Rosso's acquaintance and so deeply admired his commitment and boldness of outlook that he offered him a bronze torso in exchange for *Laughing Woman*. There is no doubt that Rosso influenced his break with conventional forms and classical traditions. Yet any imitation was purely external; in his heart Rodin was, and remained, a pure classicist and never succeeded in acknowledging Rosso's main artistic principle, which was the point of departure for his opinions and his overall philosophy of art and life. Rodin saw figures and objects in plastic terms within space, where Rosso perceived colour, atmosphere and effects of light and shade. For Rodin, line, contour and the perfect figure existed, but not for Rosso'.[18]

In contrast, Degas, like Rosso, genuinely strove, even in his sculpture, to establish dynamic spatial relationships, such as he achieved in the bas-relief *The Apple Pickers* (*c.* 1882) and the vivid series of female nudes in the act of washing, drying and combing their hair, significantly modelled in wax, which Huysmans, in *L'Art Moderne*, considered the most suitable material in sculpture to compete with painting for expressing '*la vie moderne*'.[19] Degas in the 1880s and 1890s had arrived at an interaction between form and content, and a spatial unity, which led irrevocably in his painting to the breakdown of conventional perspective, and in his sculpture in the round to an encroachment on the isolation of the statue. Just as the colour in his painting became more diffuse, the structural elements drew closer towards the foreground and closed the Albertian window with an enveloping colour-space, the material in his sculpture quivered with a tension created by freezing movement in space and light. The sensitive and mobile surfaces of these sculptures, which seem increasingly to push beyond natural bounds, are not merely a stylistic device, but the product of an entirely new way of depicting the object in space.

Beyond Impressionism?

In the 1890s, in Paris as elsewhere, many artists such as Gauguin and the Nabis showed a keen interest in anything to do with ideas, symbols and manifestations of the spirit. However, their zest for affairs of the mind and spirit – not to mention the Nabis' and the Rosicrucianists' dabblings with religion and the occult – was matched in every respect by the zeal of the positivists

and their attempts to create a realignment of forces. Along with everyone else, Rosso seems to have developed a personal response to this situation, which is already evident in *Sick Child*. Here – going beyond the shallow psychology of the 1880s – the image, without ever becoming the embodiment of an idea, is presented as a revelation of a kind of multi-dimensional reality, poised between visible and invisible elements and between consciousness and the unconscious. Much the same could be said of *Laughing Woman*, where substance is given to psychological values through the immediacy of the visual presentation rather than through metaphoric allusion or thematic references.

Rosso's interest in the psychological charge within the figure portrayed – as distinct from the emotions aroused through contemplation of the subject – becomes still more explicit in his expressive portrait of *Yvette Guilbert* (1895) (fig.10) which is vigorously sculpted on a slant and animated by the restless plane of light on its broken surfaces. The visible world provides the starting point as usual – in this case the singer's appearance on stage – but the sculptor pays special attention to the expression of psychological factors. Everything from the simplified modelling and abbreviations, attributable to the genuine effects of stage lighting, to the presentation of the subject herself in an incidental role, and the typical interpenetration of her figure with the surrounding environment, combines to create a character, who is at once corporeal and disembodied – given physical form, without recourse to evocation, allusion or idealisation. If this is not strictly a symbolist work, neither is it merely the record of a visual impression. In this case, Rosso reveals affinities with other artists of the period – not least, Toulouse-Lautrec, who used the same model and made numerous portraits of her at this time. He showed a similar interest in depicting *la vie moderne* and was representative in every way of the complex cultural climate in the last decade of the century, with its distinctly secular mood, untainted with spiritual concerns. The image is entirely naturalistic; it is shaped by events and related contingencies. *Impression on the Boulevard. Lady with the Veil* shows yet more clearly the degree of radicalism Rosso was able to bring to the emotional recording of optical data and his fidelity at the height of his maturity to the guiding principles which he established in the beginning of his career.

Even a work such as *Madame X* (1896), which is scrupulously reticent in its approach to the subject, is the material embodiment of a vision, whose physical properties are subtly modulated, yet never quite dissolved. Rosso carries this psychological elusiveness to an extreme in the *Laughing Women* and *Sick Child*. Here, suggestiveness is taken almost to the point of hermeticism and extremes of synthesis in the unified modelling, isolation of the head and almost total elimination of projecting elements. However, even in extreme cases such as these, Rosso remains once removed from the

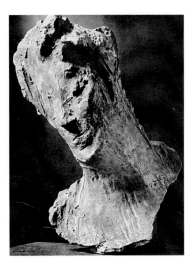

fig.10 Medardo Rosso *Yvette Guilbert* 1895 Galleria Internazionale d'Arte Moderna, Ca'Pesaro, Venice

fig.11 Medardo Rosso *Madame X* 1896 Galleria Internazionale d'Arte Moderna, Ca'Pesaro, Venice

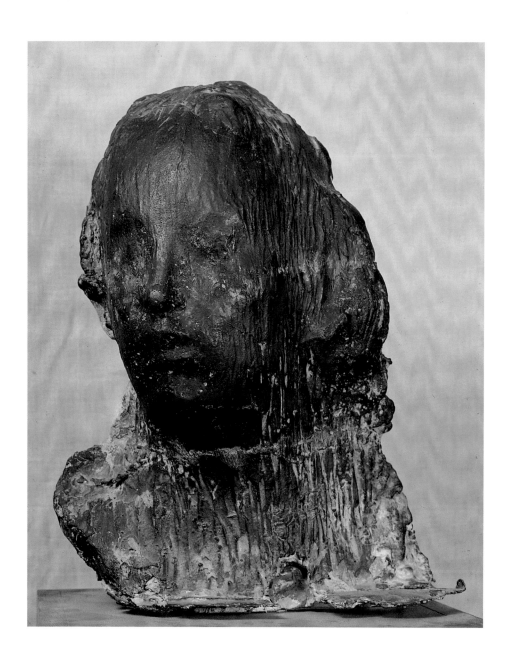

Ecce Puer 1906, bronze (cat. no. 44)

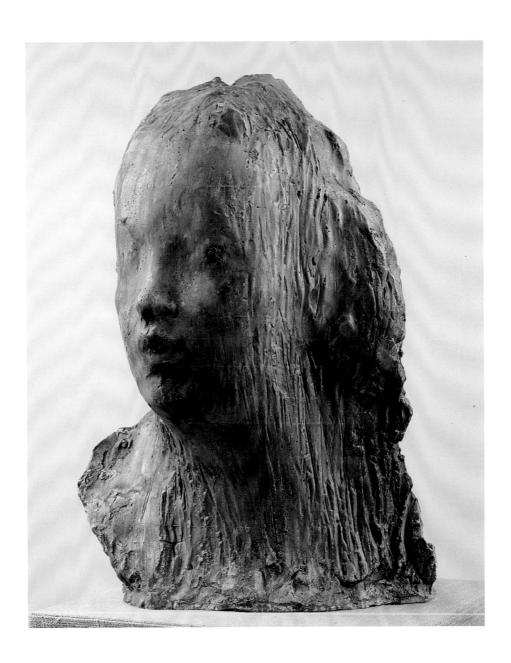

Ecce Puer 1906, plaster (cat. no. 45)

Madame Noblet 1897-98, plaster
(cat. no.42)

symbolists' attempts to reconcile 'natural science and metaphysics', to use the words of one of his admirers, Charles Morice. Thus, the rarefaction of vision does not seem to refer beyond itself to the extrasensory realm of ideas and spirituality as it does in *Ecce Puer* (1906), Rosso's last work, shown in this exhibition in the form of an original plaster model and a high-quality cast, made by the sculptor.[20]

Ecce Puer was commissioned from Rosso by Emil Mond, nephew of the collector Ludwig Mond, when the sculptor was in London for an exhibition by Cremetti (dedicatee of one of the versions of *Jewish Child* shown here). Executed before 29 December 1906, when *The Daily Chronicle* published a notice about it, *Ecce Puer* is a study of Mond's son, Alfred William. There is anecdotal evidence to suggest that the portrait was an 'impression' created by the artist after catching a fleeting glimpse of the boy in an off-guard moment, when he had already failed in repeated attempts to capture his likeness in clay. Of all Rosso's work this 'portrait' seems least inspired by any desire to render an objective account of its subject. The title, referring to Nietzsche; the greater than life-size dimensions; the softening of the features, which, particularly on the left side of the face, conceal the subject's immediate identity; and above all, the resonant evocation of the image, in its detached wholeness, reinforce the artist's intention of giving shape to a set of ideas, internal reflections and moral aspirations. Etha Fles, who was very close to the sculptor at the time, declared that he used to speak of this work as 'une vision de pureté'[21] – a definition completely in harmony with the title and the face's otherworldly absorption. The photographs which Rosso had taken of this work provide an important key to our understanding and serve to emphasise its extreme rarefaction.

Some kind of reference to the influence of symbolism on Rosso's work seems unavoidable and amply justified. This in no way contradicts the complex image which this essay attempts to construct of an artist who went beyond the narrow limits of Impressionism in the commonly understood sense of that term. The quality of *Ecce Puer* is undoubted – it ranks among the sculptor's finest achievements – yet its significance within the overall context of Rosso's output is far from clear. Our doubts are of an entirely different order. It is hard to envisage as Rosso's final work a 'vision' so entirely cerebral, detached and thought out, as to be the embodiment of his mystical leanings, if Etha Fles is to be believed (though there is no documentary evidence in support of her claim).[22] More likely, we should consider this work as a by no means insignificant episode in the artist's creative life – for the final time providing unmistakeable evidence of the unacknowledged cultural wealth of his poetic inspiration, his work and his life. The fact that this was only one episode is borne out by the dozens of drawings datable to the years after *Ecce Puer*, in which he returned to recording impressions,

sometimes of a naturalistic and descriptive variety, sometimes of a surprising simplicity, cut back to the bare essentials.

We still need to make an assessment of the strange creative 'crisis' Rosso underwent after the sublimity of *Ecce Puer*, a work presaging important new developments, which never materialised. From 1906 to his death in 1928, Rosso created no new works. Apart from making occasional drawings, he devoted all his attention to re-editing a number of his earlier sculptures – particularly those which he believed would consolidate his acknowledged position in modern sculpture. He even replicated certain more commercial works, such as *Ragamuffin*, of which he had numerous casts taken during his last years, as he had done previously, from moulds entrusted to a number of different foundries. In this final stage in his career, he is unlikely to have made these casts in person, except on an occasional basis. Nevertheless, he became much more interested in these re-editions and in experimenting with the patinas, which had always enthralled him, as well as with colouration, the effects of which became an important factor in the creation of his wax models.[23] He continued to pare down the image by cutting out one or more parts and altering the general appearance. Thus, in certain versions of *Laughing Woman* (fig. 12), he created a synthesis and surprising freshness, by eliminating, in turn, the bust and neck, which he had first brought into play a few years earlier. He then eliminated a part of the face, even to the point where almost the only remaining identifiable figurative element is the smile on the face of the subject. Rosso thus embarked on a revision of his own, not very numerous, output (he had only made about forty sculptures, some of them destined for cemeteries). Thus, he began a kind of definitive, historical reclassification of his own works which would serve to emphasise the consistency and uniformity of his artistic development over the years.

Related to this was his continual, assiduous use of photography up to the time of his death, which was caused by dropping a box of photographic plates on his foot, leading to the amputation, first of some of his toes, then of the entire leg. Contrary to widespread assumptions, Rosso did not take his own photographs, but used the services of other photographers. However, he would give instructions, work over the finished plates and occasionally crop the final print to irregular shapes to obtain the 'unique' point of view which brought out the specific qualities of a given work.

In breaking with the limitations placed on conventional statuary with its static presence and reliance on 'noble' materials – Rosso used wax and plaster as definitive materials, not merely for modelling – he quite consciously took issue with the commemorative role traditionally ascribed to sculpture and the message which it was intended to convey. The revolution that he introduced served as a point of departure, albeit in new directions, for a

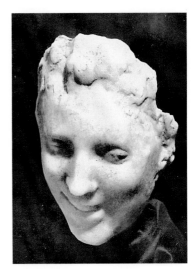

fig. 12 Medardo Rosso *Laughing Woman* 1890 (edition from the 1920s)

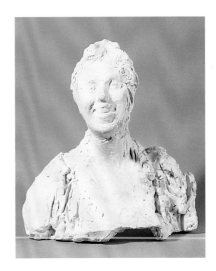

Laughing Woman (large version)
[Grande Rieuse] 1891, plaster (cat. no.29)

new generation of sculptors from Matisse (fig. 10) and Picasso to Boccioni, Duchamp-Villon and Brancusi himself. Perhaps for this reason, Rosso, in his last years, concentrated on re-fashioning what he had already made, since he probably did not share the most extreme ideas of the avant-garde. It seems that he never replied to Boccioni's letter, enclosing a copy of his manifesto. This refusal, inability or incapacity to adapt to the new culture, which was not his own, may perhaps be considered a limitation (this was how Boccioni perceived it), but it also remained a position of strength, which allowed Rosso to leave his work in a state of ordered completion, a reference point for those who, transcending the evolution of languages and styles, continued to believe in the possibility of sculpture as something essentially alive.

Translated from Italian by Henry Meyric Hughes and Jonathan Keates

NOTES

1 The *Manifesto*, published on 11 April 1912, was sent personally from Boccioni to Rosso, reconfirming the esteem the Futurist artist felt for the older master.

2 Reproductions of these works are in M. Calvesi, E. Coen, *Boccioni. L'Opera Completa*, Electa, Milan 1983 and in E. Coen, *Umberto Boccioni*, Metropolitan Museum of Art, New York 1988.

3 U. Boccioni, *Pittura e Scultura Futuriste – Dinamismo Plastico*, Milan 1914, republished in U. Boccioni, *Gli Scritti Editi e Inediti*, (ed. Z. Birolli, Feltrinelli), Milan 1971, p.191.

4 *Futurist Manifestoes*, (ed. U. Apollonio. trans. R. Brain, R. W. Flint, J. C. Higgitt, C. Tisdall), Thames and Hudson, London 1973, p.62.

5 Rosso is the 'geniale impressionista' – referred to in a letter from Paris published in the *Corriere Italiano* 29 August 1889. He is recognised as the initiator of Impressionist sculpture by Edmond Thiandière, who in October 1886 wrote in *L'Opinion* of Paris: 'Rosso makes bronze translate new impressions into powerful sketches and outlines' and 'authoritatively founds impressionist sculpture'.

6 The definitive version was published in *La Nouvelle Revue*, in the same year as the German edition, printed in Utrecht under the title *Der Impressionismus in der Skulptur* for H. de Vroede. This volume included texts by G. Geffroy, C. de St Croix, M. Bartholomé, J. Desbois, C. Pissarro, J. F. Raffaëlli and L. W. Hawkins, whereas the Paris editions also included C. Meunier, E. Frémiet, F. Charpentier, C. Claudel, C. Monet, A. Alexandre, C. Lemonnier, O. Uzanne, A. Dayot, E. Müntz, J. Faure, H. Rouart and additional texts by Rodin and Rosso.

7 E. Claris, *De l'Impressionisme en Sculpture. Auguste Rodin et Medardo Rosso*, edition of *La Nouvelle Revue*, Paris 1902, pp.1-2.

8 Ibid. pp.49-55.

9 The name 'Scapigliati' is similar to the French 'bohémiens' and is an adaptation of their anti-conventional attitude to those in authority. Its main origin is from the title of a story by C. Arrighi, *La Scapigliatura e il 6 Febbraio*, Milan, 1862. Among the principal scholars were Carlo Dossi, Emilio Praga, Giuseppe Rovani, Camillo Boito (also an architect); among the musicians, Arrigo Boito.

10 Cremona was born in Pavia in 1837 and died in Milan in 1878; Ranzoni was born in Intra in 1843, where he died in 1889; Grandi was born and died in Ganna, in 1843 and 1894 respectively.

11 For Grandi see L. Caramel, 'Lavori sconosciuti di Giuseppe Grandi' in *La Scultura nel XIX Secolo* (ed. Horst W. Janson) for the 24th Congresso del Comité International d'Histoire de l'Art, Bologna 1979, (Ed. CLUEB, Bologna 1984, pp.59-68).

12 For Cameroni and the relationship between Rosso and the Milan milieu in general, see P. Mola, 'Gli anni della formazione di Medardo Rosso alla luce di un epistolario inedito' in L. Caramel, *Medardo Rosso*, Palazzo della Permanente, Milan 1979, pp.29-46.

13 M. Rosso, 'Lettera al direttore del *Veneto*' in *Il Popolo*, 22 October 1921, republished in L. Caramel, ibid. pp.73-82.

14 E. Claris, op.cit., p.55.

15 Ibid.

16 See A. Asor Rosa in *Storia d'Italia*, IV, 2, Einaudi, Turin 1975, pp.955-99, for a useful summary of the cultural situation during these years in Italy. For the Milanese situation in particular see the text of P. Mola op.cit.

17 For reproductions and analyses of these and other drawings by Rosso, as well as those which are lost or known only through documentary photographs, see L. Caramel, *I Disegni di Medardo Rosso* in L. Caramel, P. Mola, op.cit., pp.151-74; L. Caramel, 'Medardo Rosso' in *Da Antonio Canova a Medardo Rosso. Disegni di Scultori Italiani del XIX Secolo*, Galleria Nationale d'Arte Moderna, Rome 1982; L. Caramel, *Medardo Rosso. Los Dibujos – I Disegni*, Istituto Italiano di Cultura, Madrid and Electa, Milan 1990.

18 E. Fles, *Medardo Rosso. Der Mensch und der Künstler*, W. Heinrich, Freiburg (Baden) 1922, pp. 26-27. Part of which is republished in L. Caramel, P. Weiermair, *Medardo Rosso*, Frankfurter Kunstverein 1984, pp.37-42. An Italian translation, possibly by the same author, is in the archives of the Museo Rosso in Barzio.

19 A. Lugli, *Rosso Herausforderung* in L. Caramel, P. Weiermair, op.cit., p.78.

20 Rosso's casts, in bronze or wax, are only occasionally from the artist's own hand. Rosso made expressive use of the possibilities offered by only partially removing from the bronze the residue of materials used in casting, and of other technical devices employed in the process.

21 E. Fles, op.cit., p.36.

22 Ibid.

23 Some evidence exists. For example, in a letter of 1931 to Rosso's son, Francesco, Etha Fles records that Medardo repeatedly retrieves a bronze *Sick Child* from her to change the patina.

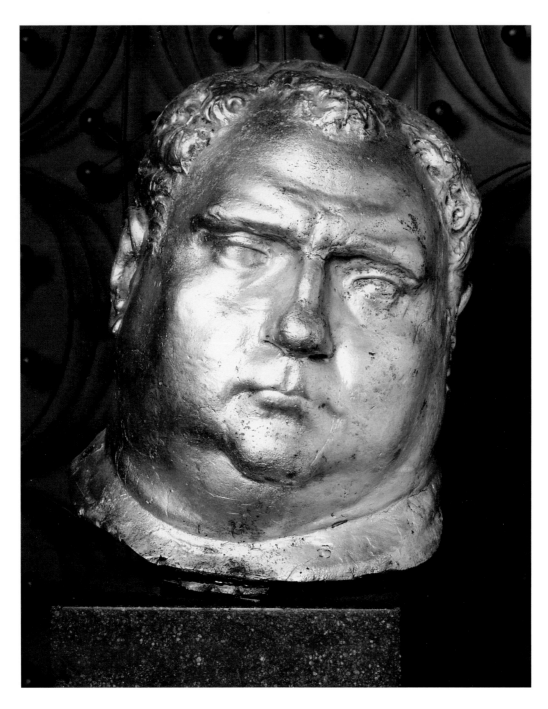

Head of the Emperor Vitellius 1894, gilt bronze (cat. no.46)

Photographs

Rosso was always directly involved with the photographic reproduction of his sculptures. Though he does not seem to have taken any of the photographs himself, he was closely involved in their creation, supervising the photographer and making adjustments to the image by the use of veiling, scratching and masking. He also altered the finished prints, often cutting them up into irregular shapes to emphasise the particular characteristics he wished to give the works. There is an obvious link here with his desire to overcome sculpture's abstract objectivity, fusing the figure with the background and establishing 'a single point of view'. They also relate to the expressive element in Rosso's work; this is apparent in his repeated alterations to photographs of *Sick Child* and *Ecce Puer*, which enhance their allusiveness and symbolic qualities.

L.C.

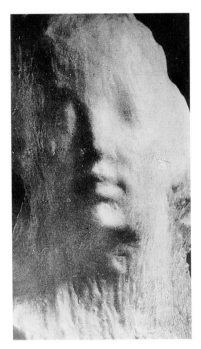

Photograph of *Ecce Puer*

'Pezzi di Paragone'

A group of works with a special place in Rosso's oeuvre are those he regarded as 'pezzi di paragone' or 'comparative works'. These are sometimes free copies from antique or Renaissance masterpieces, and sometimes authentic plaster models which were nevertheless traditionally designed works. The 'pezzi di paragone' are distinctly objective compared with the more obviously poetic inspirations that underpin his other sculptures. At exhibitions or during important visits to his studio, Rosso often placed them beside his other works to demonstrate, through juxtaposition, his belief in his own sculptures' superiority and higher artistic value, as if he were in direct competition with the past.

This was the purpose of his copy of Rodin's *Eve* which he used to demonstrate the traditionalist approach of the Frenchman and its essentially Renaissance roots, in contrast to the innovative vision of his own sculpture. This may well explain his indifference to plaster models, whether his own 'original' works or authentic antique fragments.

Another important function of these works was to provide a concrete demonstration of his gifts as a modeller, since it might otherwise have been thought that his attacks on the theory and practice of classical sculpture were motivated by a lack of technical competence.

Photograph of *Impression on the Boulevard. Lady with the Veil*

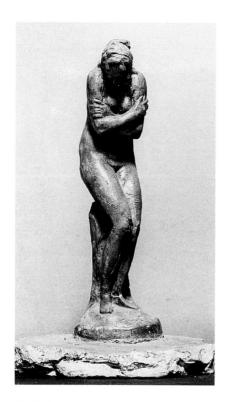

Eva by Rodin, plaster (cat. no. 50)

Rosso's works derived from the antique had a certain commercial success, especially in England, Germany and Austria, although they fetched lower prices than his other sculptures. In Vienna, for example, at the Artaria exhibition, Rosso sold his bronze *Pietà after Michelangelo Buonarotti* for 450 marks and his *Egyptian Figure* for 375 marks, whereas the *Child in the Soup Kitchen* went for 900 marks and *Woman with a Veil* for 8,600 marks. Two 'pezzi di paragone' – the *Head of the Emperor Vitellius* and the *Head of an Ancient Roman* – were sold by Rosso in 1896 to the South Kensington Museum (now the Victoria & Albert Museum).

L.C.

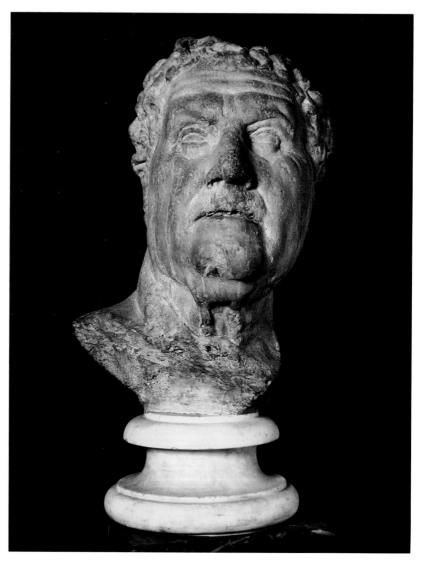

Head of an Ancient Roman 1896, composition ('matière Romaine') (cat. no. 47)

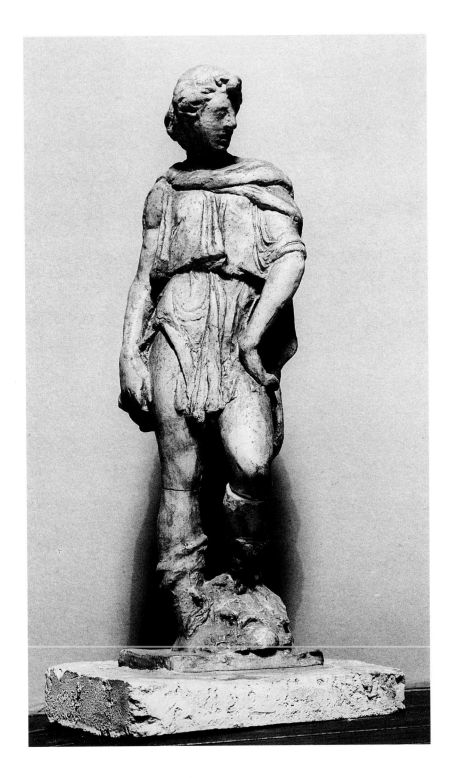

David by Donatello, plaster (cat. no. 49)

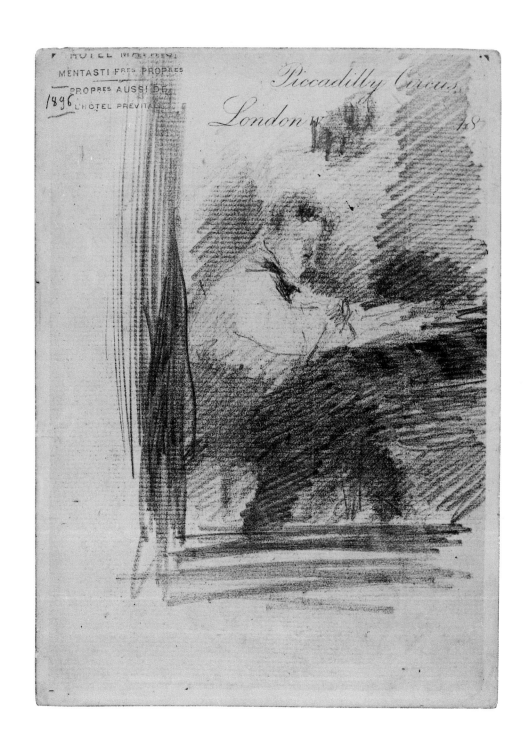

Self-portrait (?) at a Writing Desk [Autoritratto (?) allo Scrittoio] 1896 (cat. no.66)

Rosso's Drawings

VANESSA NICOLSON

The quality of apparition Medardo Rosso strove for in his sculpture gives his figures a ghost-like power which is highly arresting, but can seem initially unclear. One can sympathise with the critic Julius Meier-Graefe who in 1904 wrote: 'Rosso has come to make a sculpture that no longer resembles anything, not even sculpture'[1]. Similarly, in his drawings, it is only gradually, as with eyes growing accustomed to darkness, that shapes begin to take form, and we can identify a woman holding an umbrella, a row of trees lining an avenue, or the sea meeting the shore. Rosso realised that in real life light and shadow could distort, and that form is defined by the way light falls on it. People do not sit around in poses; their bodies move, their expressions change. If Rosso's sculpture can be likened to photography (as sculptural 'snapshots'), then the figures in his drawings seem equally to be in a continual process of shifting focus as they are caught by the artist's pen.

Rosso's self-image as a modern artist made him vociferous in his condemnation of the accepted notions of high art. His dismissal of marble monuments[2] was based on the absolute conviction that they had little or nothing to do with reflecting reality as it really was. The painter and art critic Ardengo Soffici records his friend's experience as a young man, of standing in an art gallery and being struck by the difference between the images hanging on the walls and the real people he saw around him[3]. Rosso's perception of the gallery visitors was affected by the way the light fell, and that light was continually squashing, deforming, obliterating their features so that his understanding of them was being constantly tested and changed.

Rosso's drawings are always tied to life, to the tangible world. Whether of a woman adjusting her hat or stocking, or of two figures walking along the street, hunched against the cold, we get the sense of the artist's presence, of his being there, participating in the scene. This spontaneous quality is reinforced by Rosso's habit of using whatever piece of paper came to hand when he felt inclined to sketch something he saw. Rather than carry around a sketch book, or assign the image to memory, he would often make do with the back of an old envelope, a discarded invitation or visiting card he happened to find in his pockets. He used drawing as a writer would, noting

Two Figures in the Street
[Due Figure nella Strada] 1895 (cat. no.59)

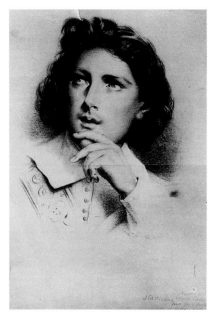

Portrait of a Youth [Ritratto di Giovane]
c. 1880-82 (cat. no. 52)

down an observation or conversation he would come across in the course of his daily life. But Rosso's sketches would not be used directly as preparatory tools to be incorporated in a larger work; there was no ulterior motive but to record what he saw.

Rosso's approach to drawing distinguishes him from Rodin, whose subjects tend to be mythological or allegorical, and who experimented with techniques such as tracing and collage to achieve different effects[4]. When Rosso occasionally sketched in red crayon or coloured ink, it was probably because he happened to have those materials with him at the time, rather than being a conscious attempt at experimentation. The differences between the two sculptors is reflected in their working methods. Rodin isolates the figure and uses drawing to understand the body's movements in order to apply that knowledge to his sculpture. Rosso, unlike Rodin, attacks the corporeality of sculpture in order to reflect the distorting power of light. The material itself – by being moulded, pressed and pulled at – is in a constant process of transformation until the right effect is achieved. This direct experimentation with the material abolished the need for a preparatory drawing, whereas for Rodin the drawing provided the starting point for working out ideas on paper before translating them into three-dimensional form. Rosso's work, both drawing and sculpture, is inspired by the same spirit – the first impression.

There are about one hundred known drawings by Rosso (compared to the thousands of drawings and watercolours by Rodin) of which about half are known only through reproductions taken from original negative plates, conserved at the Museo Rosso in Barzio. The fact that many drawings were kept and that a photographic record was made, implies that Rosso attributed some importance to his graphic work; that despite the facility and spontaneity of execution, he gave them a status above that of a mere sketch. Because so much has been recorded, a good visual record exists of Rosso's development both as a draughtsman and as a sculptor. The drawings that have survived span about fifty years, and about half of them are post 1906, when Rosso was not producing new images in sculpture but re-working old ones[5].

The style of Rosso's first existing drawing, *Portrait of a Youth*, was probably the result of a class at the Brera Academy and it sums up everything the artist was soon to reject. The drawing could be the work of any number of young art students learning the techniques of draughtsmanship: the static pose, the attention to detail and the historical references of the costume, the upturned gaze and the finished quality of the features. Nothing could be further from the direction Rosso wished to take, and his frustration at the inflexibility of this academic training made his expulsion from the Brera in March 1883 (after less than one year) inevitable[6].

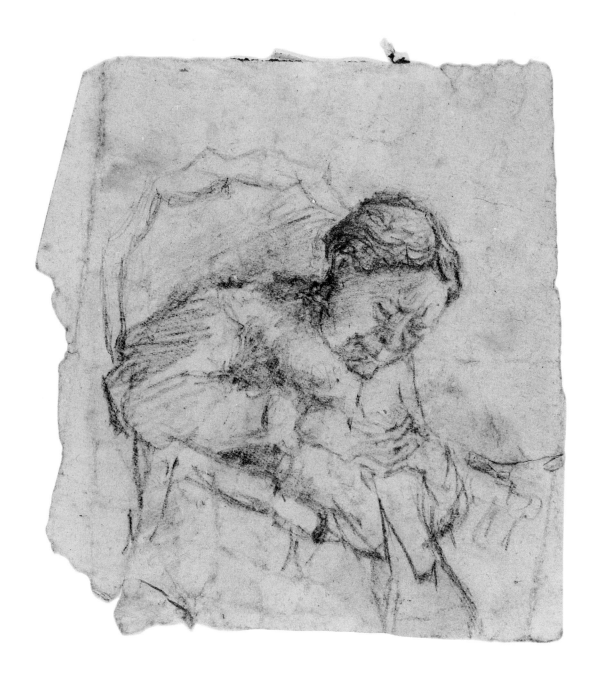

Old Woman in Armchair [Vecchia in Poltrona] 1882-84 (cat. no.53)

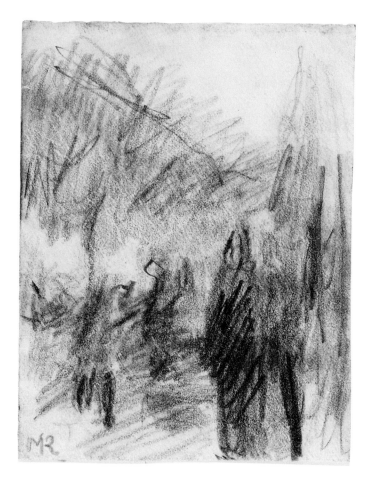

Figure of a Woman in the Street
[Figura di Donna nella Strada] 1895 (cat. no.57)

Impression of a Boulevard
[Impressione di Boulevard] 1895-96 (cat. no.61)

A number of portraits of friends and relations date from this period (1882-84). The contours begin to dissolve and the increased fluidity of Rosso's style has been likened to that of the Scapigliatura painters[7]. While the Scapigliati concentrated on smiling girls and young couples in a romantic or historical guise, Rosso's concern lay with the contemporary, with the real people disadvantaged by age, class or sickness that he saw around him. There are obvious parallels here between the drawings of old men and women and his sculptures *The Procuress*, *The Old Man*, *The Sacristan*: the curved profile of *The Concierge* can be found in his drawing, *Portrait of an Old Woman*. The old lady sitting in her armchair sewing is no doubt a portrait of Rosso's mother, whom he also depicted on her deathbed in November 1884. At this point, in both sculpture and drawing, Rosso was more interested in the play of light on the creases and crevices of lined faces and slumped shoulders, than in the smoothness of youthful features.

In the next group of existing drawings, dating about a decade later, the figure is indicated rather than described and becomes part of the general scene, of no greater or lesser importance than the surrounding objects. By this time Rosso had lived in Paris, and his experiments in introducing the effects of light and atmosphere into his sculpture had earned him considerable respect in artistic circles[8]. Some of his most radical works were executed in the mid-1890s: *Man Reading* (1894), *Impression on the Boulevard. Paris at Night* (1895) and *Conversation in the Garden* (1896).

The titles of the drawings spanning these years, *Figure of a Woman in the Street*, *Impression of a Boulevard*, etc., reveal a similar absorption with the anonymity and vibrancy of urban life. These urban inhabitants hurrying through the city streets are reduced to simplified forms emerging briefly from the shadows, only to be swallowed up again by the darkness. Rosso's fondness for tilted or raised perspectives finds expression in the elevated angle of a billiard table (*Game of Billiards*) or a road which cuts dramatically into the centre of the drawing (*Impression of a Man Going Down the Road*). This device is used most successfully in a much later drawing, *Horse Going Uphill*, in which the horse is seen from behind, from the passenger's viewpoint, with the road stretching directly in front. In a drawing of the same subject, presumably made on the same journey, the trees lining the road are more clearly delineated, and the mass of the horse's body has been carefully finished (the original of this drawing is lost). Yet the existing drawing, in its very sketchiness, is far more effective in conveying the movement of the cab, with the trees becoming a blur as the horse trots past.

In May 1896, Rosso went to London for an exhibition held at Goupil, where his work was shown next to the Pre-Raphaelites. It was a successful visit, with the South Kensington (soon to become the Victoria and Albert) Museum acquiring two 'pezzi di paragone' (comparative works)[9]. During

Game of Billiards [Partita a Biliardo] 1895
(cat. no.55)

Horse Going Uphill [Cheval qui Monte la Route] 1916-17 (cat. no.75)

Two Figures [Due Figure] 1896
(cat. no.65)

*In an Omnibus in London
[In Omnibus a Londra]* 1896
(cat. no.64)

*Man Seen from Behind
[Uomo di Spalle]* 1896
(cat. no.67)

his stay in the capital, Rosso made a good body of drawings. Due to the distance from his Parisian studio, he could turn to drawing as an alternative expressive medium, and we find him recording the atmospheric effects of the underground, the dramatic lines of the Royal Docks, of people waiting in stations, drinking in bars and walking the streets. Back in his hotel room he turns his eye on the valet packing his suitcase, or on his own reflection, framed by the mirror. He plays with perspective and composition; in the same way that he cuts across the material in his sculptures, he will turn a scene around, slicing a figure in half, opening or closing the space so that our eye remains in the foreground, or he will shift the perspective so that the scene is viewed from an unusual angle.

Rosso's dictum that the atmosphere around and between objects is of equal importance as the objects themselves, is taken to the extreme in *Man Seen from Behind*, where the space, rather than the figure is given definition[10]. It is drawn on a simple scrap of card and the figure is pale in comparison with the confident strokes of the red crayon filling the background. As with the ink drawing *Roofs*, the contours are defined by the direction of the strokes rather than by outline. In *Roofs*, and the later *Impression over the Roof Tops*, the diagonal and horizontal lines of the roofs create an overall structural system which binds them together. The resulting forms, fusing to one another and to adjacent space, recall Cézanne. (In 1895 Vollard had organised Cézanne's first one-man show, which had generated a good deal of interest among artists and critics.)

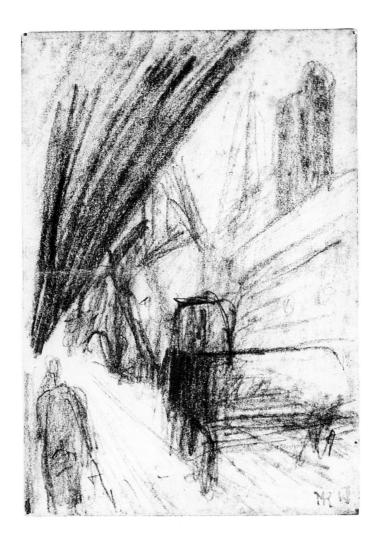

Royal Dock of London
[Royal Dock di Londra] c. 1896 (cat. no.62)

Cab en route in London
[Cab en route à Londres] 1896 (cat. no.63)

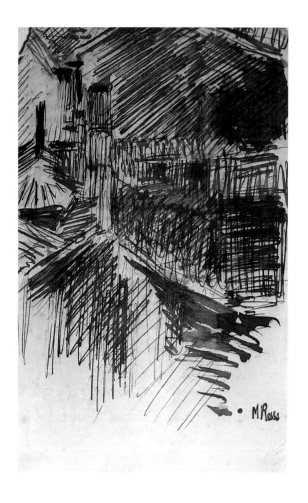

Roofs [Tetti] c. 1890s (cat. no. 54)

Impression over the Roof Tops
[Effet dessus la Toiture] c. 1920s (cat. no. 78)

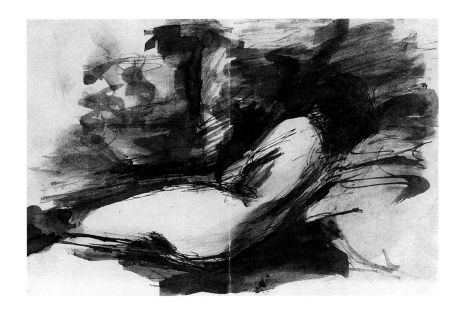

Reclining Female Nude [Nudo Femminile Sdraiato] c. 1900 (cat. no.68)

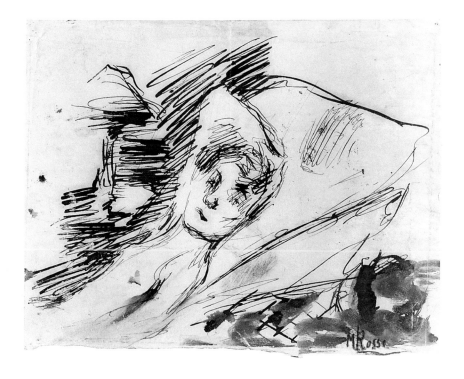

Woman on a Bed [Donna sul Letto] 1912 (cat. no.73)

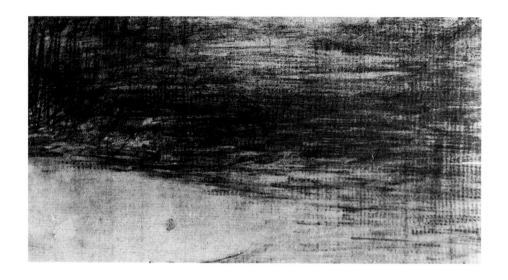

Landscape [Paesaggio] 1912 (cat. no.72)

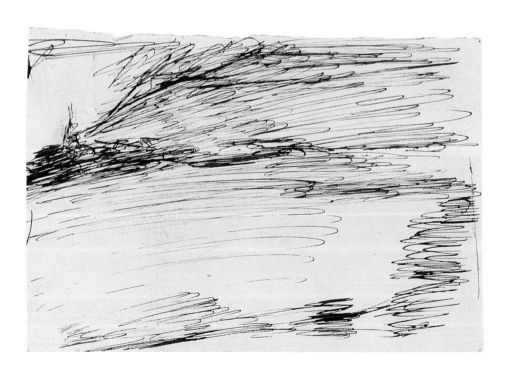

Seascape [Paesaggio al Mare] 1912 (cat. no.69)

Over a decade separates the London drawings from the next group in this exhibition. By 1912, year of the acknowledgement of his sculpture as 'revolutionary' in *The Manifesto of Futurist Sculpture* (sent to him personally by Boccioni), Rosso had achieved recognition by art critics and was beginning to be shown regularly in the most important exhibitions in Europe. Consequently he travelled more, but he also suffered from ill health, which limited his creative activity. With his portrait of Alfred William Mond of 1906 (*Ecce Puer*), Rosso's creative output had slowed down, and he turned his attention to the re-working of old themes. But he continued to sketch, and these late seascapes and landscapes thus provide an interesting addition to his oeuvre.

In the summer/autumn of 1912, Rosso was the guest of Armand Abreu at Itzas-Mendi, Armand's villa in the foothills of the Pyrenees near the Spanish border. During his stay he was involved in a serious car accident and, having been treated in hospital, he extended his visit into a period of convalescence[11]. About a dozen drawings, both in pencil and ink, depict the coastline, with the barely indicated steeple of the church and the surrounding buildings in the distance. The drawings become increasingly abstract, with the removal of any incidental object or form to detract from the sweep of the sea around the coast. Ultimately, just the movement of the sea itself becomes the subject of the drawings, conveyed simply with a few horizontal lines. *Landscape*, contains no immediately recognisable forms, but the trees, shrubs and ground are defined in terms of light and darkness, horizontals and verticals. In these late drawings, executed during periods of rest (through holiday or convalescence) away from the city[12], nature is seen as enveloping, rather than enclosed and organised into a 'scene'. Rosso once again manages to convey immediacy and atmosphere while maintaining a strong sense of composition. In *(Mountain?) Road*, the vague shadows falling on the path hint at an external presence, while the curve of the road tilting up and around into the background suggests an extension of the view beyond the confines of the frame.

Rosso returns to the human figure in his last few drawings. The women carrying out their domestic duties are seen through the window, but the wall itself plays a part in the composition, by serving as a secondary frame to these interiors. Compositionally, they recall Rosso's portrait in the mirror, of 1896. There the artist studied himself, one of the only drawings where the subject directly confronts the viewer. Here he observes women who give no indication of knowing they are being observed, and continue their business unselfconsciously. Rosso uses the pencil as if it were colour, so that by varying the degree of intensity he can pick out the immutable forms such as the balcony or the window frame, and grade the background according to the strength of the light and shade.

Landscape with Mountains [Paesaggio di Montagna] 1916-17 (cat. no.74)

(Mountain?) Road [Strada (di Montagna?)] c. 1920s (?) (cat. no.76)

Figure Leaning out (of the Balcony?)
[Figura Chinata (dal Balcone?)] c. 1920s
(cat. no.80)

Interior with Figure at the Window
[Interno con Figura della Finestra] c. 1920s
(cat. no.79)

Figure Leaning out (of the Balcony?), is arguably the most interesting of these late drawings. Rosso has "rubbed out" the top of the woman's head, and this effect combined with the diagonal of the pencil strokes, creates a movement and dynamism which would have appealed to Boccioni. Rosso's 'rubbing out' of what he has drawn and the deliberate opacity he gives to his background concentrates the eye on the figure and the atmosphere immediately surrounding her. This erasure of form may be found repeatedly in his sculpture, particularly in his late works such as *Yvette Guilbert* and *Madame X*. The 'unfinished' look of his sculpture gives the impression of an exploration on the part of the artist to find the right form that will succeed in re-creating the distorting effects of light and the fugacity of what one sees. It is this particular desire that links Rosso's sculpture to his drawings, and wherein lies his originality.

NOTES

1 J. Meier-Graefe, *Entwick-lungsgeschichte der moderne kunst*, Stuttgart 1904.

2 Rosso famously likened the beard of Michelangelo's *Moses* to a 'mass of Neapolitan spaghetti'.

3 Ardengo Soffici, *Medardo Rosso*, Florence 1929, pp.163-165. Soffici had become Rosso's friend and advocate when he saw his work at the Salon d'Automne, 1904.

4 Catherine Lampert, *Rodin Sculpture and Drawings*, Arts Council of Great Britain 1986.

5 The dating of the drawings follows that of Luciano Caramel in the catalogue of the Rosso exhibitions in Milan (1979) and Madrid (1990).

6 Rosso did not help his reputation for arrogance by thumping a fellow student who would not sign a petition he was circulating in which he criticised, among other things, the traditional methods of life drawing. Much later Rosso gave this particular drawing to his son Francesco with the dedication: 'Anca mi ho fa come tuti li altri / son sta avelena ma per poc temp ...' ('I have also done like all the others / I was poisoned only for a short time ...').

7 L. Caramel, 'La prima attività di Medardo Rosso e i suoi rapporti con l'ambiente Milanese', *Arte Lombarda*, VOL I, no.2. The anecdotal romanticism favoured by Tranquillo Cremona's early historical paintings would have been of little interest to Rosso. Cremona's later works, however, are characterised by a looser and more spontaneous style.

8 Rosso was soon discovered by the painter Henri Rouart, one of the first collectors of the Impressionists during the late 1880s. Rouart bought Rosso's work and introduced him to other clients and fellow artists (such as Degas).

9 The South Kensington Museum acquired a copy of *Head of the Emperor Vitellius* and *Head of an Ancient Roman*, copied from a bust in the Louvre.

10 See J. De Sanna, *Medardo Rosso o la creazione dello spazio moderno*, Milan, 1985, on Rosso's use of space as 'object' in his sculpture.

11 Rosso's head injury was treated at the Casa de Socorro in San Sebastian. Several of his drawings are on the headed notepaper of the Villa Itzas-Mundi, Hendaye-Plage. See L. Caramel 1979, pp.164-6.

12 A group of mountain landscapes was executed during Rosso's visits in 1916 and 1917 to his friend and patron Etha Fles in Leysin, Switzerland. See L. Caramel 1979, p.169.

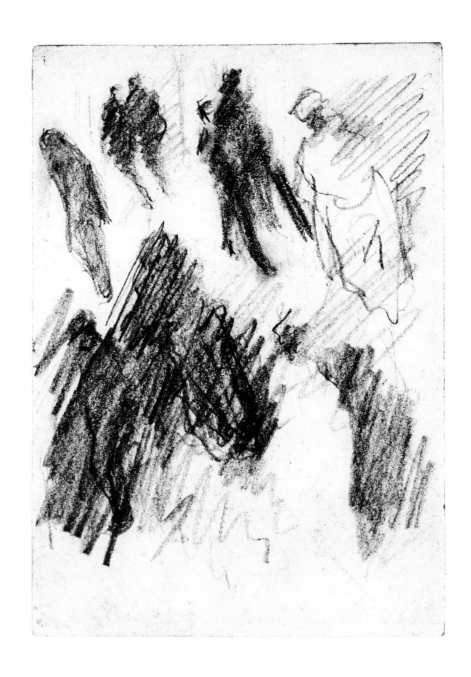

Figures [Figure] c. 1920 (cat. no.77)

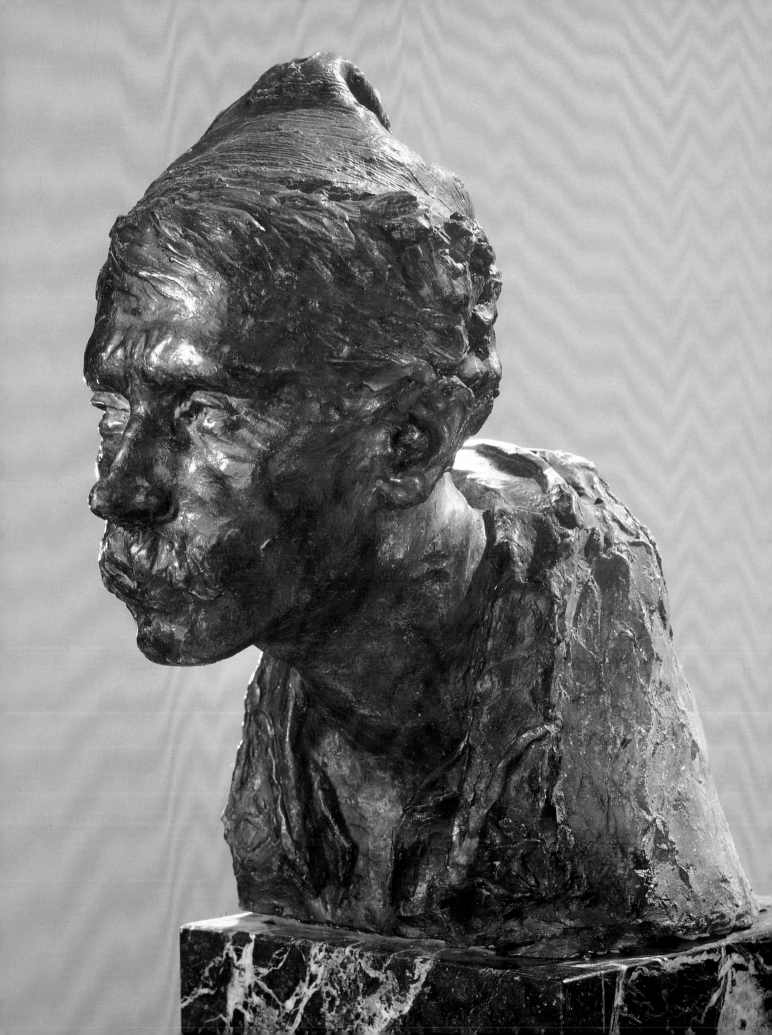

Rosso's Sculpture Technique

DEREK PULLEN

fig. 13 Impression of an Omnibus *[Impressione d'Omnibus]*

Rosso sometimes cast his own bronzes late at night in front of an invited audience. Other than these performances there are few reports of him at work, although several useful photographs of his studios have been published in previous exhibition catalogues. An account of Rosso's technique must therefore rely on a forensic approach – finding clues in the sculptures themselves and relating the clues to late nineteenth and early twentieth century sculpture techniques.

This technical approach is particularly rewarding since Rosso's small oeuvre is characterised by a few subjects in several versions and materials. The relationship between similar pieces becomes clearer when the technical processes are understood. For instance, none of the waxes examined to date are directly modelled in wax, they are all cast.

The Infantryman [Il Bersagliere] 1882-83, terracotta (cat. no. 5)

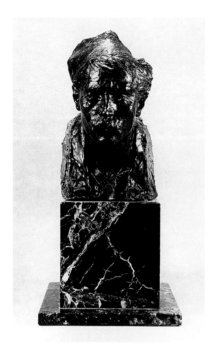

The Infantryman *[Il Bersagliere]*
1882-83, terracotta (cat. no. 5)

Rosso began a work by modelling directly in clay – no preliminary drawings survive relating to his sculptures. The details of even the earliest sculptures are vigorously modelled in a manner typical of wet clay (a photograph of *Impression of an Omnibus* (1883-84) (fig. 13), shows clay models conveniently draped with an apron of damp-looking cloth)[1]. Since a clay model cracks and crumbles as it dries, Rosso would have preserved the form by making a plaster mould of the clay. After scooping out the clay, a primary plaster would be cast into the same mould. The mould would then be chipped away to reveal the plaster – an exact match to the original clay. In the process, both the mould and clay were destroyed. It is not surprising therefore that only one fragile dried clay model survives – that of a baby's head in the private family museum at Barzio – and that no other versions of it are known to exist. Occasionally clay models, without internal armature supports, could be fired as terracottas; a version of *The Infantryman* (1882-83) is in the current exhibition.

As the clay model was destroyed by the moulding process, the primary plaster became the reference work for all later versions of the sculpture. To retain the detail of the primary plaster in subsequent castings Rosso used flexible moulds made of gelatine, often called 'glue' moulds. Rosso learnt his craft in Milan where, coincidentally, Albino Palozzolo, the foundryman who later cast Degas's fragile sculptures, claimed that he acquired the special techniques of gelatine moulding which allowed undercuts and fine surface detail to be reproduced. A visit to Milan's splendid Cimiterio Monumentale confirmed that lost-wax bronze casting flourished in the latter part of the nineteenth century; Rosso's *Monument to Filippo Filippi* (1889) being a particularly fine, if neglected, example among many.

Neither Degas' bronzes nor the elaborately detailed funerary sculptures could have been made without flexible moulds. They were usually 20-30mm thick and were supported by a plaster 'mother' mould which cradled the gelatine. Margaret Scolari Barr refers to 'shells of negative moulds' seen in photographs of Rosso's studio. Certainly a photograph of his Paris studio shows a bound plaster support mould in the foreground[2].

The gelatine was released from the primary plaster with a sharp knife. This often left discontinuous incised lines in the plaster being moulded. Several plasters have more than one set of lines indicating that extra moulds were taken. Since gelatine has a very limited shelf-life it was essential to retain the primary plaster for further mould-making at a later date.

A few versions of Rosso's sculptures include background planes which serve to frame the subjects and link them to their surroundings. *Portrait of Henri Rouart* (1889-90), now in the Openluchtmuseum in Middelheim, is an example in plaster where Rosso chose to retain the plane as a framing feature with pictorial impact. However, the backgrounds also had functional

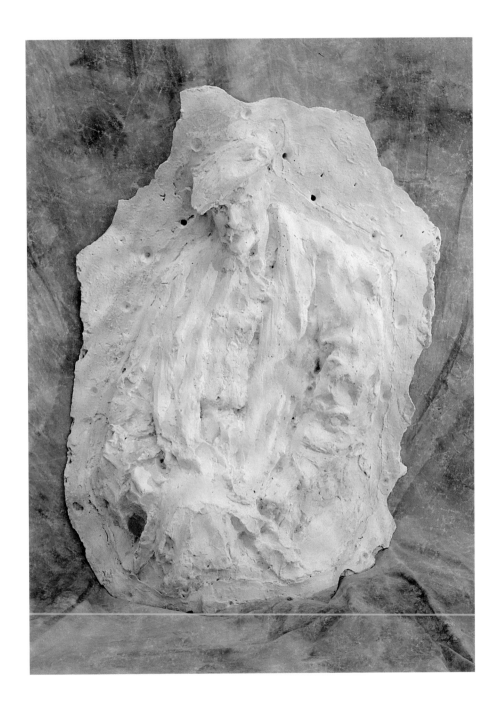

Portrait of Henri Rouart [Ritratto di Henri Rouart] 1890, plaster (cat. no.26)

roles; for subjects modelled in relief, the plane would have been present as a support for the clay from the very start, and to cast flexible moulds a background support was necessary to prevent the semi-liquid gelatine flowing around the back of the sculpture. The background left an impression in the mould which was transferred to any plaster or wax cast from it. The backgrounds were sometimes channelled or indented to provide registration points for the outer plasters, the 'mother' moulds, which cradled the floppy gelatines.

The gelatine mould could be used for casting waxes or secondary plasters. The molten wax was painted and poured into the flexible moulds to form a layer 2-4mm thick, and then back-filled with wet plaster. The mould was peeled off and left ready for further castings. A gelatine mould gave three or four sharp wax casts before it began to deteriorate. Given Rosso's interest in surface effects, blurring of details should not necessarily be taken as proof of a late or posthumous casting.

Rosso would undoubtedly have done some finishing work on his cast waxes but none of those examined show signs of extensive tooling or modelling of the surface, except for repairs. Ninety years on, the high points on some waxes are worn from handling, but there remain crevices and distinctive flash lines where mould edges met. Further evidence of casting, as opposed to modelling, are air bubbles, either trapped in the wax or reproduced as globules from the flexible moulds.

The exact compositions of Rosso's waxes are largely unknown. Beeswax of varying purity and colour seems to be the principle component but in some cases less expensive paraffin wax may have been used as an extender or substitute. Luciano Caramel comments that the earliest waxes were pale but appear to be deteriorating with age. The waxes from the Paris years (1890s and the first decade of this century) are much darker. The waxes become translucent again after Rosso's return to Italy, and especially in the 1920s.[3,4,5] Further comparative analysis of waxes might help clarify the doubts which exist over many waxes that have apparently been cast after Rosso's death.

Rosso did not edition his waxes or bronzes, apparently regarding each work as complete in itself and unique. Instead, he returned to the primary plasters as a source for further castings as circumstances demanded.

Rosso took an uncommon interest in the casting of his bronzes – a task most sculptors left entirely to the foundry. A photograph from the 1900s shows him, shirt-sleeves rolled up, manoeuvring heavy cylinders of plaster which contain either waxes ready to be burnt out (hence the 'lost-wax' method), or recently poured bronzes. A pair of assistants help dismantle the firing chamber[6]. After the poured bronze had cooled, the plaster investment material was chipped and brushed away to reveal the rough casting. A freshly cast lost-wax bronze is barely recognisable, enmeshed in a network

of bronze feeder tubes, with random fins of thin metal where molten bronze penetrated the heat-cracked plaster shell. A prolonged, laborious process of finishing with files, chasing tools and patinating chemicals was usually delegated to the foundry who aimed to achieve an evenly-patinated finish matching the primary plaster cast. Many of Rosso's most popular subjects were foundry manufactured following this procedure. Over the years different foundries would produce the same subject in bronze from secondary plasters supplied by Rosso.

Rosso's most significant bronzes, however, are those that he cast himself, controlling the process to retain some of the chance effects of casting, including matt surfaces, traces of investment in cracks, and even incomplete casts. He left some bronzes unpatinated to develop a natural oxidised patina, while others were deliberately and variably patinated to accentuate partly-finished surfaces.

Each plaster, wax or bronze sculpture can be assigned a position in a sequence leading to a finished bronze casting. Rosso exploited these intermediate stages to develop images which, in their material and finish, are obviously different from conventional sculpture of the time. Sculpture manufacture was a craft-based activity dependent on skilled artisans: armature makers, mouldmakers, casters, founders, finishers and many others. Only a practical involvement in all stages of making sculpture enabled him to take decisions which then, as now, were usually delegated to craft assistants or independent foundries.

Rosso would have developed and refined his techniques over a period of forty years, perhaps returning to old methods as well as devising new ones. The evidence is limited to the works themselves since photographs and documents published to date are not conclusive. For the most part Rosso used traditional methods to achieve unconventional results. His innovations derive from sensitive manipulation and choices based on established casting techniques. Inevitably the sculptures did not always turn out as expected, but then part of Rosso's genius lay in grasping the fleeting moment both in subject and technique.

NOTES

1 L. Caramel, *Medardo Rosso*, Palazzo della Permanente, Milan 1979, p.129

2 M. Scholari Barr, *Medardo Rosso*, Museum of Modern Art, New York 1963, pp.36,67

3 L. Caramel, unpublished communication, December 1993. L. Caramel's comments have been much appreciated and widely used in revising this text.

4 H. Bennett, *Commercial Waxes*, New York 1944

5 J.R. Gaborit, *Sculptures en cire de l'ancienne Egypte à l'art abstrait*, Paris 1987, p.342

6 L. Caramel, *Medardo Rosso*, Frankfurter Kunstverein 1984, p.60

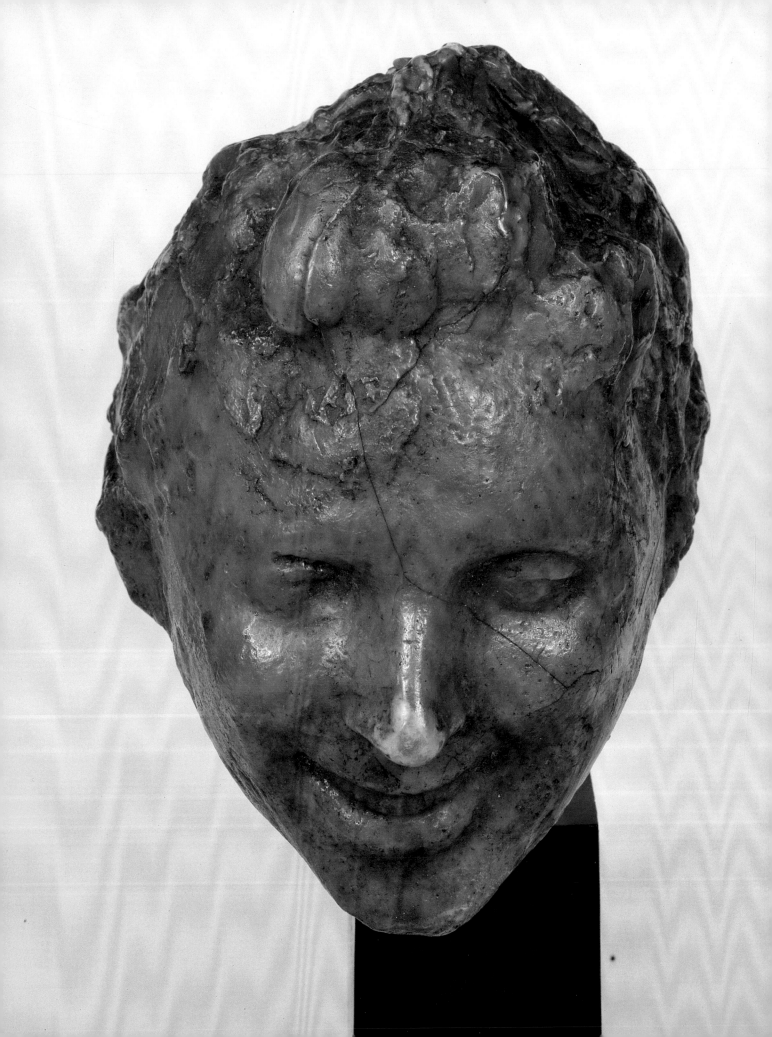

Rosso – A Change of Focus

TONY CRAGG

In the latter half of the nineteenth century, artists provoked a dramatic shift in the status of the visual image. This was perhaps in part due to the invention of photography, which seems to have called into question the validity of an artistic practice based on copying an existing reality. But it was also partly because of the creation of a class of artists who could survive in industrialised Europe without having to work for institutions like the Church, the monarchy and governments, who had traditionally commissioned artworks for their own purposes, thus restricting art, to a large degree, to allegory and symbolism and relatively simple messages. Sculptors in particular, saddled with the high cost of materials and resources necessary to make their work, seem to have directed much of their energy into fulfilling the academic requirements of their patrons.

Medardo Rosso managed to demonstrate how things could be done differently. Even if, by some standards, he had to make compromises at times, he nevertheless survived and continued his work without ever having to deviate from his own chosen concerns. More importantly, he succeeded in changing the basic understanding of the relationship between the sculptor and the material world. The sculptor was no longer a mechanic of materials, forming images that worked on the level of not very challenging symbols. Rosso transformed the practice of making sculpture into a form of thinking with material.

The process of writing is not just a question of thinking up a sentence and writing it down. The writer creates a sentence and then perhaps crosses out a few words, changes the sentence around or introduces a new word – all the time trying to access the meaning and feeling of the sentence. When the sentence is finally written it can express an entirely new thought. The act of writing seems to enable the writer to think through the writing, discovering new ideas and meanings. In the same way, a sculptor is thinking with materials. The attention and thought a sculptor invests in an otherwise meaningless piece of material is an intellectual extension of himself.

There are, however, no oral or written linguistic equivalents that describe visual experiences in anything other than the crudest of terms.

Laughing Woman (small version) [Petite Rieuse] 1890, wax (cat. no.27)

The Flesh of Others [Carne Altrui] 1883, wax
(cat. no.10)

Baby at the Breast [Enfant au Sein] 1889,
bronze (cat. no.24)

The reason for this becomes obvious when one considers the vast array of different kinds of information that constitute a visual experience. All the available materials, each displaying its own range of colour, shape and form made apparent to us by a discerning eye, constitute an alphabet, or system of signs, that make the simplest visual experience literally indescribable.

The images of materials in light that are perceived by human beings become intelligible and have meaning by virtue of the fact that they are processed by a reflected intelligence. Through this process all objects that we see become extensions of human thought and thus become part of a system of intelligence, so that the various parts of a universe full of dumb material can be put to use in an extended thought system. In a way, it is through perception that the universe becomes more meaningful. This means that the lump of material known to us as the moon can be a meaningful part of thought, whereas a landscape that has never been seen by human beings remains meaningless and uncontemplated. As intelligence is mankind's predicate for survival, it is an essential human need to know more and to incorporate as much of the universe as possible into our extended intelligence.

Intuitively and with modest means, Rosso created works in which the scale and handling of the materials demand very high definition, vision and a great deal of concentration from the observer. More importantly, his subjects, at the risk of seeming pathetic, are never grand, bombastic or heroic. The apparent fragility and sensitivity of his works enabled Rosso to achieve two historically important effects. The first is that he opened the door for sculpture to be used as an investigative discipline and set a standard for what can be expected from sculptural images, and the degree of sensibility that is required to read sculptures. The second is that he was forced to reject an energetic, virtuoso, even demonstrative, sculptural activity of the kind associated most with sculpture-making in the twentieth century.

Rosso's influence on the course of art history has not been overtly dramatic. His whole aesthetic and concerns are not those of a strong survivor. But the example that he set changed the function and focus of sculpture, taking it out of the domain of decoration and embellishment. Many major sculptors of the twentieth century have recognised this contribution and his work remains a constant reminder of the power of the visual language.

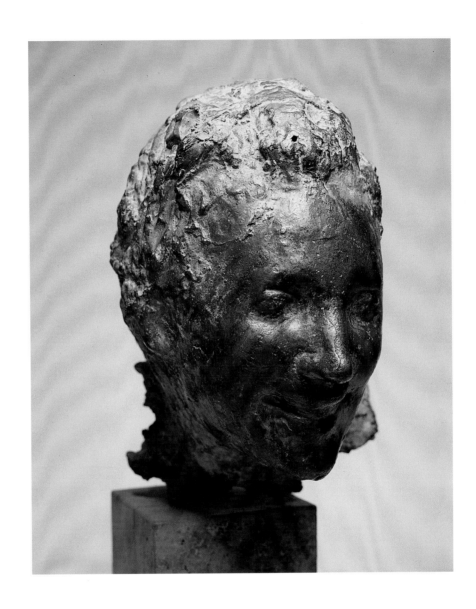

Laughing Woman (small version) [Petite Rieuse] 1890, bronze (cat. no.28)

Chronology

1858 Born 21 June in Turin, the last of three sons of Luigia Bono and Domenico Rosso (a station master).

1870 The Rosso family moves to Milan.

1879 Joins the army and is assigned to the First Regiment, Fourth Company, Sapper Brigade.

1880 Appointed quartermaster and assigned to the armoury in Pavia.
Begins to sculpt. He is also thought to have painted during this time, although no documentation exists.

1881 Discharged from the army. Leaves Pavia for Milan the same day.

1882 In May enters the Accademia di Brera, Milan, enrolling in the School of Life Drawing and Modelling.

1883 Expelled from the Accademia for putting himself 'at the head of a petition protesting against the hours of the school of life drawing and the lack of anatomical sketching from live models' and for having 'insulted and beaten ... the student Ottone Casimiro, who refused to put his name on that list of complaints, which was composed in a manner anything but that befitting proper discipline' ('Verbale dell'espulsione' reprinted in Mino Borghi, *Medardo Rosso*, Edizioni del Milione, Milan 1950, p.18).
Participates in the Esposizione Internazionale di Belle Arti in Rome. Meets the painter Baldassare Surdi and paints his portrait.

1884 Said to have visited Paris and worked in Jules Dalou's studio where he may have met Rodin, although there is no documentation in support of this.
Submits a model to the competition for the monument to Garibaldi to be erected in Milan. His mother dies in November.

1885 Marries Giuditta Pozzi, 11 April.
His son, Francesco Evviva Ribelle, is born 7 November. It is probably Francesco who is portrayed with his mother, in *The Golden Age*, dated the following year.
Exhibits *The Infantryman* at the Salon des Champs Elysées in Paris.

1886 Visits Paris and exhibits at the Salon des Indépendants.

1887 Exhibits at the Esposizione Nazionale Artistica in Venice.
Impression of an Omnibus, made in the preceding years, is destroyed in transit between Milan and Venice.

1888 Included in the Italian Exhibition at the Albert Hall, West Brompton, London in August.

1889 Dedication of the *Funeral Monument for Vincenzo Brusco Onnis* at the Cimitero Monumentale in Milan.
Leaves his wife in April.
With Felice Cameroni leaves Milan for Paris, where he stays at the Hôtel d'Enghien and exhibits at the Exposition Universelle.
Meets Zola.
Contacts are documented with Edmond de Goncourt, Paul Alexis, Luigi Gualdo, Carlo Romussi, Lucio Rossi, Michael Munkacsy, Barbedienne and Count Armand Doria, who was to become Rosso's patron.
In October admitted to the Hôpital Lariboisière in Paris, where he stays until the end of the month. Finishes *Sick Man in the Hospital* and probably also *Sick Child*. In the same year possibly also completes *Laughing Child* and meets Henri Rouart and sculpts his portrait.

1890 First contacts with the dealers Petit and Goupil are documented.
Able to afford his first studio in Paris, at 19 rue Fontaine (before this he had worked in his hotel or in the houses of patrons who commissioned his work).
Living at 52 boulevard Clichy. In the early 1890s completes *Laughing Woman (small version)*, *Laughing Woman (large version)*, *Child in the Sun*, *Jewish Boy*, and *Child in the Soup Kitchen*.

1891 Moves his studio to Rouart's *usine* on the boulevard Voltaire, where he works until 1896.
His friendship with Cameroni is over.

1893 Forms what is to be a close and lasting friendship with the Catholic socialist writer, Jean Rictus, alias Gabriel Randon de Saint Armand. Rictus is the author of several novels, all harsh depictions of the life of the poor.
Exhibits at the Bodinière on rue Saint Lazare.

1894 Lives at 19 rue Cauchois in Montmartre, at least until June.
Rodin comes to the studio and, in a note inviting him to lunch, expresses his 'wild admiration'.
Gives *Laughing Woman* to Rodin, who reciprocates by giving Rosso his *Torso*. Some time later Rosso also gives Rodin his *Head of the Emperor Vitellius*. *Bookmaker* and *Man Reading* are attributed to this year.

1895 Gives Van Gogh's *Diligence de Tarascon*, which he bought from Père Tanguy, to Milo Beretta, a young Uruguayan painter.
Yvette Guilbert and *Paris at Night* are attributed to this year. The latter is probably the work to which Rosso refers in a note to Rodin when he asks him to show a piece measuring 'three by two metres' in his 'Pavillon'.

1896 Visits London in May, where he stays at the Hotel Mathis, for an exhibition with the Pre-Raphaelites at the Goupil Gallery.
The South Kensington Museum (now the Victoria and Albert Museum) purchases two sculptures: *Head of the Emperor Vitellius* and *Head of an Ancient Roman*.

1897 *Madame Noblet* was probably made in this year.

1898 Living at 98-100 boulevard des Batignolles, his last residence in Paris.
Rodin shows his *Balzac* at the Société Nationale and references to Rosso's presumed influence appear in the press. The friendship between the two sculptors ends, and there is no further evidence of their exchanging letters.

1899 Travels to Milan, intending to abduct his fourteen-year-old son, but does not even succeed in seeing the child. His wife, who has meanwhile married the brother of the painter Barbaglia, is very distrustful and refuses to meet him.
Meets Alberto Grubicy and arranges an exhibition in Vienna.

1900 His work is shown at the Exposition Universelle in Paris. At the exhibition meets Etha Fles of the Dutch committee. An artist herself, Fles had in 1891 organised an exhibition of Symbolists in Utrecht, and in 1895 she had founded the Voor de Kunst group. She and Rosso are to remain close for many years, and she tirelessly supports him both with her critical influence and financially.
During the course of the year tries again, through Alberto Grubicy, to contact his son and makes arrangements to re-establish himself with the Milan artworld.
In the last months of the year goes to Utrecht, where he makes *Portrait of Doctor Fles*.

1901 Participates in a travelling exhibition of Impressionism organised by Fles in Amsterdam, Utrecht, The Hague, and Rotterdam. Edmond Claris publishes 'De l'Impressionnisme en sculpture: Auguste Rodin et Medardo Rosso' in *La Nouvelle Revue*. The Albertinum in Dresden acquires a wax *Sick Child* and the following year *Child in the Soup Kitchen*. His father dies in Turin 11 February.

1902 Exhibits at the Keller und Reiner Kunstsalon, Berlin and the Museum of Decorative Arts in Leipzig. Meets Julius Meier-Graefe, who will become a supporter. Becomes a naturalised French citizen.

1903 Exhibits at the Vienna Secession. On the way to Vienna, has an accident or becomes ill and is treated at the Sophienspital. After his recovery, stays at the Hôtel de France in Vienna for two months.

The Museum of Decorative Arts in Leipzig acquires a bronze *Laughing Woman*. The museum in Berlin offers 1500 marks for *Head of a Young Girl* and the Albertinum in Dresden acquires a *Head of the Emperor Vitellius*. During the first years of the century meets Dr Harald Gutherz of Graz, who becomes his friend and patron.

1904 His work is shown at the Salon d'Automne in the same room as Cézanne's *Bathers* and works by Prince Paul Troubetzkoy, the Russian sculptor who also studied at the Accademia di Brera. In a photograph of the Salon published the following year in the catalogue for the exhibition at Artaria in Vienna, Rosso has placed the small copy he had made of Michelangelo's *Madonna Medici* next to *Sick Man in the Hospital* and on the

Salon d'Automne, 1904

wall behind them were photographs of his work and of Rodin's. Ardengo Soffici publishes his first article on Rosso in *L'Europe Artiste*.

1905 One-man exhibition at the Kunstsalon Artaria in Vienna.

1906 Included in the International Society exhibition at the New Gallery, London in February-March. One-man exhibition at Cremetti, 44 Dover Street, Piccadilly in December. Stays at the Hotel Previtali.

1907 Clemenceau visits the studio at 98 boulevard des Batignolles.
Exhibits in Brussels.
The French government acquires *Impression on the Boulevard. Lady with the Veil*.

1908 Re-establishes contact with his son, Francesco, and they become close again.
Fles moves from Paris to Rome.

A campaign in support of Rosso begins in *La Voce*.

1909 Soffici's monograph, *Il Caso Medardo Rosso*, is published by B. Seeber in Florence.
Buys from Carlo Demarco a Gothic group in wood of the Virgin and Child with a saint, a fragment of a Renaissance canvas depicting the head of woman, a small Etruscan terracotta vase and a small wooden Christ. Also buys a Renaissance canvas depicting the deposition of Christ from Demarco. Exhibits at the Salon d'Automne.

1910 Prima Mostra Italiana dell'Impressionismo opens at the Circolo Lyceum in Florence with work by Cézanne, Degas, Gauguin, Matisse, Monet, Pissarro, Renoir, Toulouse-Lautrec, Van Gogh and Rosso.

1911 Exhibits in the Esposizione Internazionale di Belle Arti in Rome.

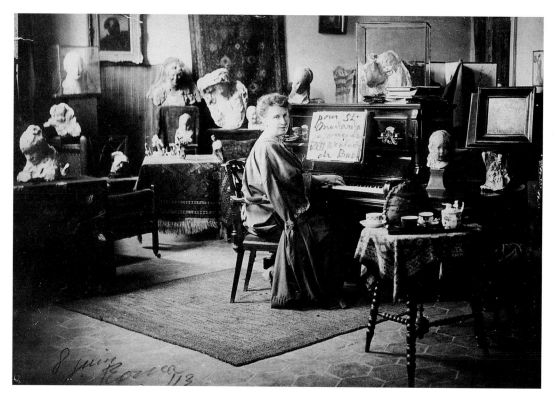

Etha Fles in Rome, 1908-9

1912 Boccioni sends Rosso the *Manifesto of Futurist Sculpture*.
Stays with Armand Abreu at Itzas-Mendi, in the foothills of the Pyrenees near the Spanish border. One day when they are returning to the villa from Bilbao the car goes off the road. Rosso suffers a serious head injury and is treated at the Casa de Socorro in San Sebastián. During his convalescence, probably in the villa at Hendaye-Plage, he makes a series of landscape drawings. Visits Paris in December.

1913 Fles returns to Holland and donates her works by Rosso to Italian museums, including those in Turin, Rome, Venice and Florence, in exchange for their acquiring a work directly from Rosso. Becomes friendly with Margherita Sarfatti, whom he might have met some time before.

1914 Shows work with Antonio Mancini, at the XI Esposizione Internazionale d'Arte della Città di Venezia.
His son accompanies him to Venice and they stay in the Bonvecchiati Hotel.

1915 During the war years, Rosso divides his time between Milan and Paris, where he often sees Amedeo Modigliani and Professor Knud Werlow, a noted translator. Also makes frequent trips to Switzerland to meet Fles in the village of Leysin.

1916 Becomes friendly with the composer Umberto Giordano, to whom he dedicates *The Concierge* now in the Museum of Modern Art in New York.

1917 Rodin dies 17 November.
Decides to give Rodin's *Torso* to Gustavo Sforni, who has recently bought two of Rosso's works.

1918 Apollinaire writes in *L'Europe Nouvelle* that Rosso is working in his studio (in Paris) on a figure of a horse.
Spends longer periods of time in Milan, where he often sees the painter Carlo Carrà.

1920 Exhibits in the Mostra d'Arte Sacra in Venice.

1923 Along with fourteen other artists, named National High Advisor of the Plastic Arts for

his 'noble contribution to the visionary heritage of Italy'.
One-man exhibition at the Bottega di Poesia in Milan. Benito Mussolini attends the opening. The furniture in the studio/apartment on boulevard des Batignolles in Paris is seized because the rent has not been paid and he cannot be found.

1926 Shows six works at the Exhibition of Modern Italian Art at the Grand Central Art Galleries in New York.
Invited to participate in the Prima Mostra d'Arte del Novecento Italiano at the Palazzo della Permanente, Milan.
Ecce Puer is purchased for the museum in Piacenza.

1928 Sends *Child in the Soup Kitchen* to the International Exhibition of Painting and Sculpture in Madrid.
Injures his foot when photographic plates fall on it and is taken to the Evangelico clinic on via Monterosa in Milan.
First several toes are amputated, then his leg. His heart does not withstand the second operation, and on 31 March he dies.

L.C.

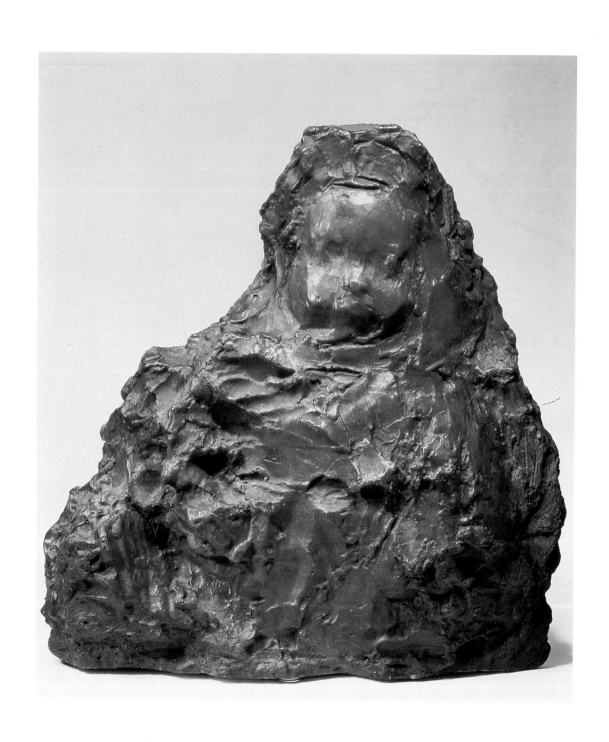

Child in the Soup Kitchen [Bambino alle Cucine Economiche] 1892, wax (cat. no. 37)

Further Reading

A. Soffici, *Il Caso Medardo Rosso*, (ed. B. Sceber), Florence 1909

E. Fles, *Medardo Rosso, der Mensch und der Künstler*, Walter Heinrich
 Verlag, Freiburg (Baden) 1922

A. Soffici, *Medardo Rosso*, (ed. Vallecchi), Florence 1929

E. Cozzani, *Medardo Rosso*, L'Eroica, Milan 1931

G. Papini, *Medardo Rosso*, Hoepli, Milan 1940 (2nd ed. 1945)

N. Barbantini, *Medardo Rosso*, Neri Pozza Editore, Venice 1950

M. Borghi, *Medardo Rosso*, Edizione del Milione, Milan 1950

L. Caramel, 'La prima attività di Medardo Rosso e i suoi rapporti con
 l'ambiente milanese', in *Arte Lombarda*, vi. 2. 1961

M. Scolari Barr, 'Medardo Rosso and his Dutch Patroness Etha Fles'
 in *Nederlands Kunsthistorische Jaarboek*, 13, 1962, pp.217-251

M. Scolari Barr, *Medardo Rosso*, The Museum of Modern Art,
 New York 1963

L. Caramel, *Mostra di Medardo Rosso*, Palazzo della Permanente,
 Milan 1979

L. Caramel, *Da Antonio Canova a Medardo Rosso – Disegni di Scultori
 Italiani del XIX Secolo*, Galleria Nazionale d'Arte Moderna,
 De Luca, Rome 1982

L. Caramel, P. Weiermair, *Medardo Rosso*, Frankfurter Kunstverein,
 Frankfurt 1984

J. De Senna, *Medardo Rosso o la Creazione dello Spazio Moderno*, Mursia,
 Milan 1985

L. Caramel, *Medardo Rosso*, Kent Fine Arts, New York 1988

L. Caramel, *L'Impressionismo nella Scultura*, Galleria Coray and Electa,
 Lugano 1989

E. Braun (ed.), *Italian Art in the 20th Century*, Royal Academy of Arts,
 London and Prestel-Verlag, Münich 1989

L. Caramel, *Medardo Rosso. Los Dibujos – I Disegni*, Palacio de Abrantes,
 Madrid and Electa, Milan 1990

M. Fagioli, *Medardo Rosso* (2 vols.), San Miniato, Florence 1993

List of Works

SCULPTURE

1 *The Spiv [El Locch]*
1881-82
Bronze, 38 x 28 x 34.5 cm
Galleria Nazionale d'Arte Moderna, Rome
(London only)

2 *The Ragamuffin [Gavroche* or *Il Birichino]*
1882-83
Bronze, 27 x 32 x 19 cm
Galerie de France, Paris

3 *The Ragamuffin [Gavroche* or *Il Birichino]*
1882-83
Bronze, 32 x 32 x 23.5 cm
Private Collection, Switzerland

4 *The Ragamuffin [Gavroche* or *Il Birichino]*
1882-83
Plaster, 36 x 29 x 25 cm
Private Collection, Switzerland

5 *The Infantryman [Il Bersagliere]*
1882-83
Terracotta, 40.6 x 25.4 x 38.1 cm
The Hakone Open-Air Museum

6 *Kiss under the Lamp-post*
[Gli Innamorati sotto il Lampione]
1882-83
Bronze, 28.5 x 25.5 x 26.5 cm
Museo Medardo Rosso, Barzio

7 *Unemployed Singer [Il Cantante a Spasso]*
1882-83
Bronze, 27.3 x 9 x 8 cm
Private Collection

8 *The Procuress [La Ruffiana]*
1883
Bronze, 33 x 25.2 x 22 cm
The Hakone Open-Air Museum

9 *The Old Man [Il Vecchio]*
1883
Bronze, 28.8 x 16 x 17.8 cm
The Hakone Open-Air Museum

10 *The Flesh of Others [Carne Altrui]*
1883
Wax, 30 x 38 x 21 cm
Private Collection

11 *The Flesh of Others [Carne Altrui]*
1883
Wax, 23.5 x 22.5 x 16 cm
Galerie de France, Paris

12 *Maternal Love [Amor Materno]*
1883
Bronze, 39 x 28 x 20 cm
Private Collection

13 *The Sacristan [Lo Scaccino]*
1883
Bronze, 33 x 30 x 14.5 cm
Private Collection

14 *The Sacristan [Lo Scaccino]*
1883
Plaster, 46.5 x 31.5 x 31.5 cm
Museo Medardo Rosso, Barzio

15 *The Concierge [La Portinaia]*
1883-84
Wax, 37.5 x 29 x 17 cm
Private Collection

16 *The Concierge [La Portinaia]*
1883-84
Bronze, 38 x 35 x 16 cm
Private Collection, Torricella

17 *Portrait of Carlo Carabelli*
[Ritratto di Carlo Carabelli]
1886
Bronze, 53.5 x 26.5 x 17.5 cm
Museo Medardo Rosso, Barzio

18 *The Golden Age [Aetas Aurea]*
1886
Bronze, 47.9 x 36 x 28 cm
Private Collection

19 *Sick Man in the Hospital [Il Malato all'Ospedale]*
1889
Bronze, 21.5 x 26 x 19 cm
Galleria Pieter Coray, Lugano

20 *Sick Man in the Hospital [Il Malato all'Ospedale]*
1889
Wax, 20.8 x 30.5 x 19.2 cm
The Hakone Open-Air Museum

21 *Sick Child [Bambino Malato]*
1889
Plaster, 25.5 x 23 x 17.5 cm
Private Collection

22 *Sick Child [Bambino Malato]*
1889
Wax, 25.7 x 26 x 15.2 cm
Private Collection, Geneva

23 *Sick Child [Bambino Malato]*
1889
Bronze, 27 x 14.5 x 16.5 cm
Galleria d'Arte Moderna, Milan

24 *Baby at the Breast [Enfant au Sein]*
1889
Bronze, 32 x 42 x 41 cm
Museo Medardo Rosso, Barzio

25 *Laughing Child [Bambina che Ride]*
1889-90
Wax, 27.5 x 18 x 19 cm
Kamakura Gallery, Tokyo

26 *Portrait of Henri Rouart [Ritratto di Henri Rouart]*
1889-90
Plaster, 120 x 83 x 33 cm
Openluchtmuseum voor Beeldhouwkunst,
Middelheim

27 *Laughing Woman (small version) [Petite Rieuse]*
1890
Wax, 23.5 x 17.5 x 15.5 cm
Private Collection

28 *Laughing Woman (small version) [Petite Rieuse]*
1890
Bronze, 28.5 x 25 x 21 cm
Pieter Coray, Lugano
(London and Edinburgh only)

29 *Laughing Woman (large version) [Grande Rieuse]*
1891
Plaster, 53.9 x 50.8 x 15.2 cm
The Hakone Open-Air Museum

30 *Laughing Woman (large version) [Grande Rieuse]*
1891
Bronze, 60 x 68 x 38 cm
Galleria d'Arte Moderna di Palazzo Pitti, Florence
(London only)

31 *Jewish Boy [Bambino Ebreo]*
1892-93
Wax, 23.7 x 10.9 x 13.2 cm
The Hakone Open-Air Museum

32 *Jewish Boy [Bambino Ebreo]*
1892-93
Bronze, 26 x 17 x 18 cm
Museum Folkwang, Essen

33 *Jewish Boy [Bambino Ebreo]*
1892-93
Wax, 24.5 x 15 x 17 cm
Private Collection

34 *Impression on the Boulevard. Lady with the Veil
[Impression de Boulevard. La Femme à la Voilette]*
1893
Wax, 60 x 59 x 25 cm
The Eric and Salome Estorick Family Foundation

35 *Child in the Sun [Bambino al Sole]*
1892
Wax, 37.5 x 26 x 24 cm
Private Collection

36 *Child in the Soup Kitchen
[Bambino alle Cucine Economiche]*
1892
Bronze, 43 x 38 x 17 cm
Galleria d'Arte Moderna di Palazzo Pitti,
Florence

37 *Child in the Soup Kitchen
[Bambino alle Cucine Economiche]*
1892-93
Wax, 48 x 45.5 x 13 cm
Private Collection

38 *Bookmaker*
1894
Bronze, 43 x 35 x 36.5 cm
Galleria d'Arte Moderna, Milan

39 *Man Reading [Uomo che Legge]*
1894
Bronze, 30 x 31 x 30 cm
Galleria d'Arte Moderna di Palazzo Pitti,
Florence

40 *Man Reading [Uomo che Legge]*
1894
Wax, 28.7 x 33 x 32 cm
Private Collection

41 *Conversation in the Garden
[Conversazione in Giardino]*
1896
Bronze, 32 x 66.5 x 41.5 cm
Galleria Nazionale d'Arte Moderna, Rome
(London only)

42 *Madame Noblet*
1897-98
Plaster, 64.5 x 52.5 x 45.5 cm
Museo Medardo Rosso, Barzio

43 *Madame Noblet*
1897-98
Bronze, 51.5 x 49 x 37 cm
Galleria d'Arte Moderna, Milan

44 *Ecce Puer*
1906
Bronze, 42.5 x 33.5 x 23 cm
Galleria Internazionale d'Arte Moderna
Ca'Pesaro, Venice

45 *Ecce Puer*
1906
Plaster, 46.2 x 43 x 32 cm
Scottish National Gallery of Modern Art,
Edinburgh (London and Edinburgh only)

'PEZZI DI PARAGONE'

46 *Head of the Emperor Vitellius*
1894
Gilt bronze, 31 x 25 x 26 cm
Trustees of the Victoria & Albert Museum

47 *Head of an Ancient Roman*
1896
Composition ('matière Romaine'),
38 x 22.2 x 27 cm
Trustees of the Victoria & Albert Museum

48 *Madonna Medici by Michelangelo*
1904
Plaster, 25 x 11.5 x 14 cm
Museo Medardo Rosso, Barzio

49 *David by Donatello*
n.d.
Plaster, 37.5 x 10.5 x 8 cm
Museo Medardo Rosso, Barzio

50 *Eva by Rodin*
n.d.
Plaster, 25 x 11.5 x 14 cm
Museo Medardo Rosso, Barzio

PAINTING

51 *Portrait of Baldassare Surdi*
1883
Oil on canvas, 79 x 58 cm
Private Collection

DRAWINGS

52 *Portrait of a Youth [Ritratto di Giovane]*
c. 1880-82
Pencil and charcoal on paper, 51 x 35.2 cm
Museo Medardo Rosso, Barzio

53 *Old Woman in Armchair [Vecchia in Poltrona]*
1882-84
Pencil on paper, 12 x 11 cm
Museo Medardo Rosso, Barzio

54 *Roofs [Tetti]*
c. 1890s
Ink on paper, 21.9 x 14.1 cm
Museo Medardo Rosso, Barzio

55 *Game of Billiards [Partita a Biliardo]*
1895
Pencil on paper, 15 x 10 cm
Museo Medardo Rosso, Barzio

56 *Impression of a Man Going down the Road*
 [Effet d'Homme (qui) Descend la Route]
 1895
 Pencil on paper, 17.7 x 19.1 cm
 Museo Medardo Rosso, Barzio

57 *Figure of a Woman in the Street*
 [Figura di Donna nella Strada]
 1895
 Pencil on paper, 15.2 x 4.6 cm
 Museo Medardo Rosso, Barzio

58 *Figure of a Woman (in the Mirror?)*
 [Figura Femminile (allo Specchio?)]
 1895
 Pencil on paper, 11.5 x 9.8 cm
 Museo Medardo Rosso, Barzio

59 *Two Figures in the Street*
 [Due Figure nella Strada]
 1895
 Pencil on paper, 12 x 6.5 cm
 Museo Medardo Rosso, Barzio

60 *Woman Adjusting her Stocking*
 [Donna che si Aggiusta la Calza]
 1895-96
 Ink on paper, 24 x 11.3 cm
 Museo Medardo Rosso, Barzio

61 *Impression of a Boulevard [Impressione di Boulevard]*
 1895-96
 Pencil on paper, 11.8 x 9 cm
 Museo Medardo Rosso, Barzio

62 *Royal Dock of London [Royal Dock di Londra]*
 c. 1896
 Pencil on paper, 17.9 x 12.8 cm
 Private Collection, Milan

63 *Cab en route in London [Cab en route à Londres]*
 1896
 Pencil on paper, 9.4 x 6.4 cm
 Museo Medardo Rosso, Barzio

64 *In an Omnibus in London [In Omnibus a Londra]*
 1896
 Pencil on paper, 12 x 7.5 cm
 Museo Medardo Rosso, Barzio

65 *Two Figures [Due Figure]*
 1896
 Pencil on paper, 12.9 x 7 cm
 Museo Medardo Rosso, Barzio

66 *Self-portrait (?) at a Writing Desk*
 [Autoritratto (?) allo Scrittoio]
 1896
 Pencil on paper, 18.5 x 13 cm
 Museo Medardo Rosso, Barzio

67 *Man Seen from Behind [Uomo di Spalle]*
 1896
 Chalk on paper, 12.8 cm x 13.4 cm
 Museo Medardo Rosso, Barzio

68 *Reclining Female Nude [Nudo Femminile Sdraiato]*
 c. 1900
 Ink on paper, 11 x 18 cm
 Private Collection, Milan

69 *Seascape [Paesaggio al Mare]*
 1912
 Ink on paper, 11.5 x 17 cm
 Museo Medardo Rosso, Barzio

70 *Impression of the Sea [Impressione Marina]*
 1912
 Pencil on paper, 13.8 x 21.3 cm
 Museo Medardo Rosso, Barzio

71 *Impression of the Sea [Impressione Marina]*
 1912
 Pencil on paper, 10.8 x 15.5 cm
 Museo Medardo Rosso, Barzio

72 *Landscape [Paesaggio]*
 1912
 Pencil on paper, 11 x 21 cm
 Museo Medardo Rosso, Barzio

73 *Woman on a Bed [Donna sul Letto]*
 1912
 Ink on paper, 13 x 18 cm
 Private Collection, Milan

74 *Landscape with Mountains [Paesaggio di Montagna]*
 1916-17
 Pencil on paper, 12.6 x 7.2 cm
 Museo Medardo Rosso, Barzio

75 *Horse Going Uphill [Cheval qui Monte la Route]*
 1916-17
 Charcoal and pencil on paper, 20.6 x 12 cm
 Museo Medardo Rosso, Barzio

76 *(Mountain?) Road [Strada (di Montagna?)]*
 c. 1920s (?)
 Pencil on paper, 14.7 x 11.8 cm
 Museo Medardo Rosso, Barzio

77 *Figures [Figure]*
 c. 1920
 Pencil on paper, 18 x 12.9 cm
 Private Collection, Milan

78 *Impression over the Roof Tops*
 [Effet dessus la Toiture]
 c. 1920s
 Pencil on paper, 22 x 14 cm
 Museo Medardo Rosso, Barzio

79 *Interior with Figure at the Window*
 [Interno con Figura dalla Finestra]
 c. 1920s
 Pencil on paper, 11.2 x 9.3 cm
 Museo Medardo Rosso, Barzio

80 *Figure Leaning out (of the Balcony?)*
 [Figura Chinata (dal Balcone?)]
 c. 1920s
 Pencil on paper, 12.9 x 7.3 cm
 Museo Medardo Rosso, Barzio

All photographs and archival items
are from the Museo Medardo Rosso
in Barzio.

Lenders to the Exhibition

Barzio, Museo Medardo Rosso
Edinburgh, Scottish National Gallery of Modern Art
Eric and Salome Estorick Foundation
Essen, Museum Folkwang
Florence, Galleria d'Arte Moderna
Hakone, The Open-Air Museum
London, The Trustees of the Victoria & Albert Museum
Lugano, Galleria Pieter Coray
Middelheim, Openluchtmuseum voor Beeldhouwkunst
Milan, Galleria d'Arte Moderna
Paris, Galerie de France
Rome, Galleria Nazionale d'Arte Moderna
Tokyo, Kamakura Gallery
Venice, Galleria Internazionale d'Arte Moderna Ca'Pesaro
Private Collections